D0575969

REVOLUTION
OF
THE EYE

MODERN ART
AND
THE BIRTH OF
AMERICAN
TELEVISION

Maurice Berger

Introduction by
Lynn Spigel

The Jewish Museum, New York
Under the auspices of the Jewish
Theological Seminary

Center for Art, Design and
Visual Culture
University of Maryland,
Baltimore County

Yale University Press
New Haven and London

REV
OLU
TION
OF
THE
EYE

This book has been published in conjunction with the exhibition *Revolution of the Eye: Modern Art and the Birth of American Television*, organized by The Jewish Museum, New York, and the Center for Art, Design and Visual Culture, University of Maryland, Baltimore County.

The Jewish Museum, New York,
 May 1–September 20, 2015
Museum of Art | Fort Lauderdale,
 Nova Southeastern University, Florida,
 October 17, 2015–February 28, 2016
The Addison Gallery of American Art,
Andover, Massachusetts, April 9–
 July 31, 2016
Center for Art, Design and Visual Culture,
 University of Maryland, Baltimore
County, October 20, 2016–January 8, 2017
The Smart Museum of Art, University of
 Chicago, February 16–June 11, 2017

Copyright © 2014 The Jewish Museum, New York, and Yale University. "Revolution of the Eye: Modern Art and the Birth of American Television" and "Modern Art and Early American Television: A Cultural Timeline" copyright © 2014 Maurice Berger. Introduction copyright © 2014 Lynn Spigel. Artwork copyrights and photographic credits appear on pages 154–55.

All rights reserved. This book may not be reproduced, in whole or in part, including illustrations, in any form (beyond that copying permitted by Sections 107 and 108 of the US Copyright Law and except by reviewers for the public press), without written permission from the publishers.

The Jewish Museum
Director of Publications: Eve Sinaiko
Editor: Anna Jardine
Proofreader: Sylvia Karchmar

Designed by Abbott Miller, Jesse Kidwell,
 and Yoon-Young Chai, Pentagram
Set in Schmalfette Grotesk,
 Akzidenz-Grotesk, and Fakt
Separations by Professional Graphics, Inc.
Printed in China by Regent Publishing
Services Limited

The Jewish Museum
1109 Fifth Avenue
New York, New York 10128
thejewishmuseum.org

Center for Art, Design and Visual Culture
University of Maryland, Baltimore County
1000 Hilltop Circle
Baltimore, MD 21250
www.umbc.edu/cadvc

Yale University Press
PO Box 209040
New Haven, CT 06520–9040
yalebooks.com/art

Library of Congress Control Number:
2014941272
ISBN 978-0-300-20793-4

A catalogue record for this book is available from the British Library.

The paper in this book meets the requirements of ANSI/NISO Z39.48–1992 (Permanence of Paper).

10 9 8 7 6 5 4 3 2 1

Cover: Detail of a still from Andy Warhol, *Outer and Inner Space*, 1965; see page 112.

Frontispiece: Detail of James Rosenquist, *Aspen, Colorado*, 1966; see page 140.

FOREWORDS

We are now fifteen years into the twenty-first century, no longer standing at the turn of the millennium. As the raucous twentieth century recedes from memory and enters history, its great events, its wars and achievements are duly documented and analyzed. Among these is the invention of television, acknowledged as a key element in the radical cultural changes that have occurred in the past hundred years: mass communications, mass entertainment, mass politics.

But rarely is TV discussed in terms of art—and when it is, critics have usually focused on the ways television has influenced high art, or been critiqued and ridiculed by it. Yet as network television now shares the stage with other forms of broadcasting and video dissemination, we can see the ways in which this popular, commercial mechanism aided art, responded to art—and was, many times, itself art.

In bringing this fascinating exhibition to fruition, and its accompanying catalogue to print, the Jewish Museum is proud to offer viewers and readers a fresh perspective on a much-maligned form of creativity, one that deserves, and now receives, a closer look. We welcome you to the exploration of this complex form of art.

Revolution of the Eye would not have been possible without the extraordinary efforts of many. Our collaboration with the Center for Art, Design and Visual Culture at the University of Maryland, Baltimore County, has been a pleasure from start to finish; I thank Symmes Gardner, executive director, most warmly. The project curator, Maurice Berger, is a force of nature and has achieved prodigies on a tight schedule and budget. The production companies, networks, artists, collectors, and other individuals who have made rare footage, objects, and images available to us have been more than generous. As always, our Board of Trustees has been a dedicated, engaged, and supportive partner. It is my great pleasure to offer them all my deep gratitude.

Claudia Gould
Helen Goldsmith Menschel Director
The Jewish Museum

Over the past thirty years, the academic and cultural worlds have seen—and welcomed—a breakdown of the rigid boundaries of media and methodology that have defined disciplines. The resulting emphasis on interdisciplinary practices has altered the way we view culture. I can think of no more important precursor for understanding the power of interdisciplinary communication than the story of *Revolution of the Eye*. Tracing the powerful synergy between visual artists and the pioneers of early television, it illuminates a relatively unknown history of a medium that most of us engage in our daily lives.

Revolution of the Eye is of particular importance to the Center for Art, Design and Visual Culture, as it exemplifies our fundamental mandate to focus on the interconnections among disciplines. Previous projects have explored the relationship of art, design, and material culture to a range of diverse subjects, including American race relations, ecology, gender studies, genetics, housing and urban planning, museum studies, science, and social history.

Revolution of the Eye is the result of a generative collaboration between the Jewish Museum and the Center. I am immensely grateful to the Jewish Museum and its director, Claudia Gould, for working together with us to produce this groundbreaking project. At the University of Maryland, Baltimore County, I would like to acknowledge the support and encouragement we have received for *Revolution of the Eye* from Dr. Freeman Hrabowski, president; Philip J. Rous, provost; Dr. Karl V. Steiner, vice-president for research; and Dr. Scott E. Casper, dean of the College of Arts, Humanities, and Social Sciences. And a special thanks go to Dr. Maurice Berger, research professor and chief curator at the Center for Art, Design and Visual Culture, for his tenacity and focus in helping to bring about this collaboration and for his exemplary work on *Revolution of the Eye*.

Symmes Gardner
Executive Director
Center for Art, Design and Visual Culture,
University of Maryland, Baltimore County

DONORS AND LENDERS TO THE EXHIBITION

Revolution of the Eye: Modern Art and the Birth of American Television is made possible by the generous support of the Andy Warhol Foundation for the Visual Arts, the Stern Family Philanthropic Foundation, the National Endowment for the Humanities: Celebrating 50 Years of Excellence, the National Endowment for the Arts, and an anonymous donation in memory of Curtis Hereld.

Endowment support is provided by The Skirball Fund for American Jewish Life Exhibitions, and the Neubauer Family Foundation.

Addison Gallery of American Art, Andover,
 Massachusetts
Jennifer Bass, Culver City, California
Saul Bass Collection at the Academy Film Archive,
 Los Angeles
Electronic Arts Intermix, New York
Fraenkel Gallery, San Francisco
Jewish Museum, New York
Kramlich Collection, San Francisco
The Herb Lubalin Study Center of Design and
 Typography, The Cooper Union
Museum of Art | Fort Lauderdale, Nova
 Southeastern University
The Museum of Modern Art, New York
Newark Museum
Pace/MacGill Gallery, New York
Private collection
Kevin Roche John Dinkeloo and Associates,
 Hamden, Connecticut
Sonnabend Gallery, New York
Estate of Stan VanDerBeek, New York
The Andy Warhol Museum, Pittsburgh

PREFACE AND ACKNOWLEDGMENTS

During my graduate studies in the 1980s, I was passionately interested in television as a popular art form. But I was discouraged from researching a subject that my advisors regarded as unworthy of study. Much has changed in the intervening thirty years: cultural history has emerged as a robust academic field, scholarship about the medium has blossomed, and more recently, researchers and writers have focused on the rich relationship between modern art and television in its formative years in the United States.

Building on this work, *Revolution of the Eye: Modern Art and the Birth of American Television* explores the cultural and social context into which television was born and, conversely, the myriad ways in which society at large responded to the new medium. It examines the modernist aesthetic and principles that have influenced American television from its inception in the late 1930s—artistic ideas and ideals that continue to influence the medium today—as well as the extent to which early television introduced the public to the latest trends in art and design and to avant-garde artists. In so doing, it helps restore to the museum a history that remains mostly unknown but that still affects our everyday lives.

Revolution of the Eye represents the culmination of a fruitful collaboration between the Jewish Museum in New York, where I am Consulting Curator, and the Center for Art, Design and Visual Culture at the University of Maryland, Baltimore County, where I hold the position of Research Professor and Chief Curator. I would like to thank my colleagues at CADVC who have contributed to this project in innumerable ways: Professor Symmes Gardner, Executive Director; Sandra Abbott, Curator of Collections and Outreach;

William John Tudor, Exhibitions and Technical Designer; Janet Magruder, Business Manager; and my diligent research assistants Graca McKenney, Melanie Feaster, and Rebecca Pristoop. In addition, I would like to thank key members of the UMBC community for their ongoing and generous support of the project: Dr. Freeman Hrabowski, President; Philip J. Rous, Provost; Dr. Karl V. Steiner, Vice President for Research; Greg Simmons, Vice President, Office of Institutional Advancement; Dr. Scott E. Casper, Dean of the College of Arts, Humanities, and Social Sciences; Professor Vin Grabill, Chair, Department of Visual Arts; and Professor Timothy Nohe, Director, Center for Innovation, Research, and Creativity in the Arts.

My colleagues at the Jewish Museum have been supportive of and attentive to the needs of *Revolution of the Eye* from its inception. I thank them enthusiastically: Claudia Gould, the Helen Goldsmith Menschel Director of The Jewish Museum; Ruth Beesch, Deputy Director, Program Administration; Jens Hoffmann, Deputy Director, Exhibitions and Public Programs; Ellen Salpeter, Deputy Director, External Affairs; Jennifer Ayres, Exhibitions Manager; Nelly Silagy Benedek, Director of Education; Elyse Buxbaum, Director of Institutional Giving; Dr. Susan L. Braunstein, Curator; Christopher Gartrell, Coordinator of Adult Programs; Al Lazarte, Senior Director of Operations and Exhibition Services; Julie Maguire, Senior Registrar; Claudia Nahson, Curator; Anne Scher, Director of Communications; Colin Weil, Director of Marketing; Roy Rub, Consulting Creative Director; Aviva Weintraub, Associate Curator; Jenna Weiss, Coordinator of Public Programs; and Susan Wyatt, Senior Grants Officer.

The project has profited from the sage advice and analytical rigor of a team of consultants, whom I owe a debt of gratitude: Dr. Morris Dickstein, Distinguished Professor of English and Theatre, and Senior Fellow of the Center for the Humanities, Graduate Center of the City University of New York; Michelle Elligott, Chief of Archives, The Museum of Modern Art, New York; Dr. Susan Felleman, Professor of Art History and Film and Media Studies, University of South Carolina; Dr. Michele Hilmes, Professor of Media and Cultural Studies, Department of Communication Arts, University of Wisconsin–Madison; Norman L. Kleeblatt, Susan and Elihu Rose Chief Curator, the Jewish Museum; Dr. Mason Klein, Curator of Fine Arts, the Jewish Museum; Ellen Lupton, Curator of Contemporary Design, Cooper-Hewitt, National Design Museum, New York, and Director of the Graphic Design MFA program, Maryland Institute College of Art (MICA), Baltimore; Dr. Horace Newcomb, former Lambdin Kay Chair for the Peabodys, Grady College of Journalism and Mass Communication, University of Georgia; Dr. Lynn Spigel, Frances E. Willard Professor of Screen Cultures, School of Communications, Northwestern University; and Dr. Haidee Wasson, Associate Professor of Film Studies and Associate Dean of Research and Graduate Studies, Concordia University.

Over the past twenty years, I have been lucky to be affiliated with the National Jewish Archive of Broadcasting at the Jewish Museum, first as a member of its board of advisors and now as curator. The archive, four thousand programs strong, was established in 1981 to collect, preserve, and exhibit television and radio programs related to the Jewish experience. The opportunity to work with the archive has been a boon; it has been both an important resource and a font of ideas and inspiration for *Revolution of the Eye*.

The project's audiovisual component has benefited from the extraordinary work of its film editor and AV consultant, Niger Miles, AV Director at the Jewish Museum, and its licensing and rights consultant, Lewanne Jones, an Emmy-nominated archival producer, research director, rights manager, and documentary archivist. At the Jewish Museum, the project was aided by the rigor and insights of my research assistants, Emily Casden, Emily Markert, and Kelly Taxter. Joanna Montoya Robotham, Neubauer Family Foundation Assistant Curator at the museum, attended to the innumerable details of the project with skill, grace, and intelligence. I would like to acknowledge Eve Sinaiko, Director of Publications, for her excellent editorial oversight, which contributed greatly to the exhibition and book. At Yale University Press, I would like to thank Patricia Fidler, Katherine Boller, Sarah Henry, Heidi Downey, and Laura Hensley. Once again, Anna Jardine delivered superb editing of the manuscript. Abbott Miller, a partner in Pentagram's New York office, has provided a design and visual campaign for the exhibition and the book that are at once breathtaking, historically rich, and brilliant. His work has gone far in making *Revolution of the Eye* the best it could be.

I would like to acknowledge the support of my colleagues at The Ed Sullivan Show/SOFA Entertainment for their generous gift of research footage and clips for the exhibition: Andrew Solt, Greg Vines, Mary Sherwood, and Josh Solt. I thank the following colleagues for their advice and support:

Laura Beiles, Dan Cameron, Bonnie Clearwater, Aebhric Coleman, Thulani Davis, Donna DeSalvo, Judith Dolkart, Henry Louis Gates Jr., Pablo Helguera, Anthony Hirschel, Antonio Homem, Allison Kemmerer, Kathryn Potts, David Roediger, Irving Sandler, Danielle Schwartz Shapiro, Stephanie P. Smith, Ann Temkin, Alexander Tochilovsky, Michelle Wallace, John Waters, David Weinstein, and Sam Yanes.

I heartily thank the following friends and family for their encouragement, ideas, and counsel: Joanne Leonhardt Cassullo, Faith Childs, Katherine Dieckmann, James Estrin, David Gonzalez, Alvin Hall, Ronald Heiferman and Judy Miller, Diane Keaton, Francine Klagsbrun, Mason Klein and Elizabeth Sacre, Barbara Kruger, Therese Lichtenstein, Barbara Buhler Lynes, Niger Miles, Steve Miller, Alicia Hall Moran and Jason Moran, Joanna Montoya Robotham, Joan Rosenbaum, Sarah Rothenberg, Amy Schewel, and Oliver Wasow and Dana Hoey. Finally, I reserve my greatest thanks and appreciation for my husband, Marvin Heiferman, for his wisdom, inspiration, steadfast support, and love.

Maurice Berger

INTRODUCTION
Lynn Spigel

In 1926, the architect and artist Frederick Kiesler predicted that "telemuseums" would one day send art through the airwaves. "Just as operas are now transmitted over the air, so picture galleries will be," he enthused. "From the Louvre to you, from the Prado to you, from everywhere to you. . . . Through the dials of your Teleset you will share in the ownership of the world's greatest art treasures."[1] Although Kiesler's dream of the telemuseum did not quite come true, television and the visual arts do share a long and often surprising history. *Revolution of the Eye* offers a unique opportunity to explore the largely forgotten relationship between commercial television and the visual arts during the 1950s and 1960s—the decades when television became the primary form of entertainment and information.

The rise of American television after World War II occurred at a time when the United States became an international center for modern art and design. The postwar decades witnessed what critics called an "arts explosion" in almost every medium, from painting to music to architecture to graphic design. Attendance at art galleries and museums skyrocketed during the 1950s, and amateur painting became a popular craze. The American home itself was a canvas for all manner of midcentury modern designs—from Eames chairs to boomerang coffee tables to Technicolor fridges to, of course, the new TV sets and the endless stream of "tele-decor" (TV tables, TV lamps, TV chairs) that accompanied them. But more than just furniture, television played a major role in the integration of art into everyday life, offering its first publics a new kind of virtual gallery that flickered on living room screens across the nation.

At the most basic level, the visual arts—especially painting and graphic design—served the television industry's need to hold audiences' attention with visual attractions. Yet given television's commercial nature, the display of art on television was tempered by demands to gather a mass audience composed of viewers from across the nation, many of whom did not have a taste for the urbane world of modern art. In this context, TV typically presented art through the language of family values and popular entertainment. Cultural affairs shows such as CBS's *Omnibus* gave lessons on Dada, Surrealism, and Abstract Expressionism, but muted the more radical aspects of the various avant-gardes with homey advice. In a 1953 episode, the host Alistair Cooke discussed Marcel Duchamp's *Nude Descending a Staircase*. Admitting that abstraction was "rather frightening" to people, Cooke demonstrated how abstract painting had influenced fabric designs for women's dresses. "Spring is coming up, and here is an abstraction," he proclaimed, holding up a frock.

For their part, art museums around the nation—from New York to Boston to Detroit to St. Louis to San Francisco—quickly understood the value of television for extending their reach to the new-TV homes, and like the networks they sought to make art entertaining. In 1952, the Museum of Modern Art in New York (MoMA) initiated a "Television Project" and developed programs with the housewife and family audience in mind. Museum officials appeared on local morning shows where they spoke to housewives about good design, while MoMA's educational show *Through the Enchanted Gate* encouraged the cultivation of the "creative child." Similarly, in 1951,

the San Francisco Museum of Art (now SFMoMA) premiered its *Art in Your Life* television series, which dealt with such domestic topics as "Furniture for Modern Living."

Meanwhile, network dramas told stories about modern art. In line with a long tradition of popular skepticism about modern art (and its European roots), series such as *Climax!* and *I Led Three Lives* featured evil modernists who, during the McCarthy "Red Scare" era, were often portrayed as a threat to American values. In particular vogue were stories about sexually promiscuous bad-girl models who posed for modern artists. By 1967, stories about evil modernists had become so cliché that ABC's Pop Art–inspired *Batman* devoted a two-part episode to the Joker's art crimes in Gotham.

But television was more than a window for the display of modern art. It was also an art medium itself, promoting new visual techniques in set design, graphic design, animation, montage, and color, and even experimental filmmaking. In the early 1950s, the broadcast networks developed in-house TV art departments that became centers of modern design. A leader in the field, CBS built its quality reputation as the "Tiffany network" largely on the artistic talents of its advertising and art departments, headed by the graphic designers William Golden (famous for his trailblazing publicity art, including his development of the CBS eye) and Georg Olden (a pioneer of title design, and one of the first African Americans to hold an executive post at a network).[2] CBS also hired prominent architects to design its then ultramodern studio, Television City in Los Angeles (William Pereira and Charles Luckman, 1952), and its corporate headquarters in New York, known as

"Black Rock" (Eero Saarinen, 1965). More generally, all three networks—as well as advertisers, TV stations, and program producers—hired prominent designers, animators, and photographers, among them Ben Shahn, Andy Warhol, Paul Strand, Lou Dorfsman, David Stone Martin, Paul Rand, Gene Deitch, John J. Graham, Richard Avedon, and Saul Bass, to create publicity, station IDs, on-screen title art, and other visual attractions.

Artists also developed new forms of TV montage and motion graphics. In the early 1950s, as part of its Television Project, MoMA hired the avant-garde filmmaker Sidney Peterson to create experimental films for TV that used modernist principles of cinematic montage. The designers Charles and Ray Eames, with their musical partner, Elmer Bernstein, and the animator Dolores Cannata, experimented with film, montage, sound, and animation sequences for the CBS specials *The Fabulous Fifties* and *The Good Years*, which aired in the early 1960s. But the most prolific TV artist was Ernie Kovacs, whose various series, from morning shows to game shows to TV specials, ran through the 1950s and until his untimely death in 1962. Kovacs's complex visual montages, experiments with sound and image relations, and absurdist skits (a gorilla ballet; silent commercials) led critics of his time to compare his work to Surrealism and Dada. In subsequent years, critics hailed him as a video art pioneer.

Ironically, given the oft-cited disdain for TV commercials, advertising turned out to be the hallmark of artistic experimentation. United Productions of America (UPA) and other animation studios used abstract or semiabstract designs (often with whimsical humor) to give mundane

products such as beer and breakfast cereal a modern, progressive feel. Embracing the modern art of commercials, MoMA featured some of these ads at its UPA exhibition in 1955, and also worked with UPA on an animated film, *The Invisible Moustache of Raoul Dufy*, for its Television Project. By the 1960s, advertisers applied art cinema techniques— jump cuts, rapid montage, and split screen—to supermarket products such as Tab soda and Zee napkins. Commenting on the trend, the filmmaker Stanley Kubrick observed: "Some of the most imaginative filmmaking, stylistically, is to be found in TV commercials."[3] The media theorist Marshall McLuhan deemed the TV commercial as a visual form so cutting-edge that it even primed audiences for new sensory experiences at the movies. *What's New Pussycat?* (1965) and *A Hard Day's Night* (1964), he argued, "would prove unacceptable as mass audience films if the audience had not been preconditioned by television commercials to abrupt zooms, elliptical editing, no story lines, flash cuts."[4]

Despite the enthusiasm, television's commercial imperatives often mitigated the more radical potential of modern art. Even for people who were not necessarily interested in avant-gardism, television was, by the 1960s, already a national disappointment. In 1961, the Federal Communications Commission chairman Newton N. Minow called television a "vast wasteland," a term that became a catchphrase for all that was wrong with the medium. To be sure, network programs were notoriously symptomatic of the period's racial exclusions and gender ideologies. Still, whatever its failings, television did offer possibilities for intervention. In 1957, Duke Ellington presented his jazz suite *A Drum Is a Woman* as a special presentation on *The United States Steel Hour*, a network anthology drama series. This "jazz fantasy," as Ellington called it, featured an all-black cast and used modern dance to act out the history of jazz and the Black Diaspora. The fantasy culminated in the "Ballet of the Flying Saucers," an outer-space modern dance sequence that prefigured the Afrofuturism of later decades. By 1968, in a more explicitly political fashion, CBS aired a seven-part documentary series, *Of Black America*. In the first installment, the series' narrator, Bill Cosby, delivered an alternative history of art, showing how European modernists had "stolen" from African arts.

By the end of the 1960s, when advertisers were hoping to woo younger demographics, Pop, Op, and psychedelic art had made their way to the small screen. *Rowan & Martin's Laugh-In*, its title inspired by counterculture sit-ins and be-ins, presented topical satire by mixing old variety-show vaudeville aesthetics (such as musical vamps) with the imagery of new art movements, including a colorful, psychedelic "joke wall" out of which cast members popped to deliver "zingers." For his part, the Pop superstar Andy Warhol made his own versions of Pop TV. Having created TV title art in the 1950s and experimented with new video technologies since the 1960s, by the 1980s, Warhol had turned to the fledgling Manhattan cable outlets to create his own series. The last of these, *Andy Warhol's Fifteen Minutes*, aired on MTV from 1985 to 1987. As the person best known for turning commerce into art, Warhol provides a fitting conclusion to this exhibition. His television used the commercial formats of network TV—talk shows, fashion shows, soap operas—to explore alternative sexualities and

drag club culture. He also showcased such artists, filmmakers, and musicians as Cindy Sherman, John Waters and Divine, Larry Rivers, and Debbie Harry, and experimented with video techniques, color, and interview methods.

Despite the deep connections between television and art, museums have paid little attention to modern art and design as it appeared on commercial TV.[5] When it comes to aesthetics, historians have focused more often on television's recycling of previous popular arts such as movies, radio, circus, and vaudeville. Rather than offer this backward glance, *Revolution of the Eye* examines television's contribution to the "shock of the new" in postwar culture. Today, as the visual environment is increasingly dominated by digital screens, this exhibition helps us think about television's effect on the production and reception of art in contemporary culture. Even more profoundly, it asks us to consider the radical potential of media—even commercial media such as TV—to provide new ways of looking at the world.

NOTES

1. Frederick Kiesler, *Contemporary Art Applied to the Store and Its Display* (New York: Brentano's, 1930), 121. Kiesler first envisioned the telemuseum for the Société Anonyme exhibition at the Brooklyn Museum in 1926. Although he did not manage to produce the telemuseum for that exhibition, he did produce a simulated version for a 1927 exhibition at the Anderson Galleries in New York. See Mary Anne Staniszewski, "Museum as Website, Archive as Muse: Some Notes and Ironies of Conventions of Display," *Convergence: The International Journal of Research into New Media Technologies* 6, no. 10 (June 2000): 10.

2. Although the eye was created during Golden's tenure as art director, it was a collaborative effort, especially involving the artist Kurt Weihs. See William Golden, "My Eye," *Print* 13, no. 3 (May–June 1959): 32–36. Some speculate that Georg Olden was also involved in the creation of the CBS eye. See Julie Lasky, "The Search for Georg Olden," in *Graphic Design History*, ed. Steven Heller and Georgette Balance (New York: Allsworth, 2001), 115–28.

3. Stanley Kubrick, as quoted in Hollis Alpert, "Is It Strangelove? Is It Buck Rogers? Is It the Future?" *New York Times*, January 16, 1966, 43.

4. Marshall McLuhan and Quentin Fiore, *The Medium Is the Massage: An Inventory of Effects* (1967; repr., Berkeley, CA: Gingko, 1996), 128.

5. Several pathbreaking exhibitions have focused on television's relation to video art and painting and other media. Notable here are *Television's Impact on Contemporary Art*, the Queens Museum, New York, September 13–October 26, 1986, and *The New Frontier: Art and Television, 1960–65*, Austin Museum of Art, Austin, Texas, 2000.

A NOTE ON THE TEXT

The following texts—one an analytical overview, the other a timeline—are meant to be read in relation to each other. The first examines the cultural, social, and aesthetic factors that motivated and defined the interchange between modern art and early television. The second provides historical details. Rather than present a comprehensive history, these two texts together recount important moments and ideas from a largely unrecognized past.

REVOLUTION OF THE EYE

MODERN ART
AND
THE BIRTH OF
AMERICAN
TELEVISION

Maurice Berger

Both the visionaries and the social scientists have seen television as a thing, an influence in people's lives. . . . Both groups have, in many cases, chosen to ignore the fact that television is a particular kind of thing, a particular version of influence. Though it is capable of various sorts of communication, television most often carries entertainment in dramatic form. It is an artistic medium, but it has not been examined as an art.

Horace Newcomb,
TV: The Most Popular Art

On March 30, 1966, *Color Me Barbra*, an hourlong musical special showcasing the formidable talent of its sole performer, Barbra Streisand, was broadcast nationwide on CBS. A year earlier, *My Name Is Barbra*, her visually innovative first television special, filmed on spare and elegant sets and in sumptuous black-and-white, helped catapult the vivacious twenty-three-year-old Broadway sensation to even greater superstardom. *Color Me Barbra*, promoting the all-color prime-time lineup introduced by CBS that season, was similarly artistic, its schematic sets and locations evoking the early twentieth century heyday of modern art, the mood in keeping with Streisand's nostalgic musical repertoire.

In one of the program's three "acts," an extensive fantasy sequence, Streisand is filmed on location at the Philadelphia Museum of Art. Dressed as a French chambermaid, she glides through the museum's imposing lobby, climbs its marble stairway, and enters its galleries. In the modern art rooms, she transforms from servant to vibrant personification of the objects around her, a moving and breathing work of art outfitted in a brightly colored Op Art dress and huge geometric earrings. Streisand belts out a rousing song, "Gotta Move," in which she yearns for a "brand-new place" where no one will tell her "what to be and how to be it, someplace where I can just be me."[1] Her exuberance suggests that she has found what she was looking for, albeit in the elitist realm of an art museum.

The fantasy of modern art as a locus of self-expression is underscored in the next scene. Streisand, again dressed as a maid, encounters a painting by Amedeo

Stills from *Color Me Barbra*, CBS, 1966.

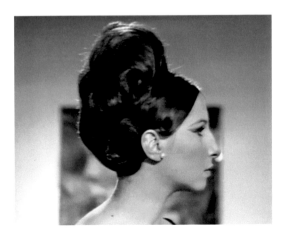

Modigliani, *Portrait of a Polish Woman* (1919). It instantly comes to life, with the singer assuming the clothes and pose of the elegant sitter and crooning "Non, C'est Rien," the songwriter Michel Jourdan's world-weary paean to love and loss.[2] Streisand does not so much re-create Modigliani's masterpiece as escape into it—from a world of servitude to that of an exotic muse, singing in French no less, the language then most popularly associated with the avant-garde.

These scenes represent a convergence of two interrelated cultural forces: television and modern art. In the two decades leading up to *Color Me Barbra*, the pioneers of American television—a great number, like Streisand, young, politically liberal, Jewish, and aesthetically adventurous—had adopted the avant-garde as a source of inspiration. For many, television's novel technology, and its modernist sources, would forge a path to freer expression and cutting-edge aesthetics. Television was, in its formative years, undoubtedly limited by corporate interests and cultural restrictions and prejudices. But its initial distribution in largely urban areas, its lower expectations (compared with the more established film industry, for example), its lack of long-standing technical and conceptual conventions, and its freedom to experiment, made television particularly appealing to those entertainers, producers, directors, designers, and writers who, also like Streisand, were searching for a place in which to rise above the status quo, or, at least, to expand its boundaries. Ultimately, for these pioneers, modern art was the epitome of cultural experimentation and creativity, a model for shaping a brash new medium.

While much art historical research has focused on the high-culture institutions that have supported and defined avant-garde art—from galleries and museums and alternative spaces to journals and university art departments—there has been far less analysis of the complex, fraught, and often productive relationship between high art and the institutions of popular culture. Indeed, to date, there has been no exhibition on the subject of high art's influence on American television, and only one book, Lynn Spigel's groundbreaking *TV by Design: Modern Art and the Rise of Network Television*.[3]

Revolution of the Eye focuses on the period in which television emerged as a dominant medium of communication in the United States, from the late 1940s through the early 1970s. The project demonstrates how the best of the dynamic new medium, with its imperative to experiment and extend the limits of entertainment, paralleled the visual and conceptual dynamism of modern art. And it looks at the social, political, and economic forces that shaped this relationship—from the politics of the Cold War to the corporate interests of networks that embraced modernist

sensibilities and ideals in order to associate their companies with "good taste and the democratic ideals of enlightenment."[4]

While art historians and curators have examined the influence of popular culture on a distinctly American postwar avant-garde, they have typically treated fine art as the privileged discipline, sidestepping or ignoring the question of how mass media, especially television, acted as a vehicle for the wide-scale dissemination of modern visual forms. The neglect of television also ignores its authority within society as one of the most influential and life-altering visual technologies of the modern era, a medium so important and compelling that Marshall McLuhan deemed it a "spectacular extension of our central nervous system."[5]

The pioneers of early television understood the medium's innate power, and they mined the aesthetic, stylistic, and conceptual possibilities of a new and powerful technology. They understood, as well, that television could affect not only culture but also public opinion on issues from the Cold War and McCarthyism to the rise of feminism and the struggle for civil rights. For the latter, perhaps more than any other social issue, continual television news coverage of major events and conflagrations—including the violent confrontation of activists and police in Birmingham, Alabama, in May 1963 and the March on Washington that August—was instrumental in swaying public opinion.[6]

Fictional television also engaged political debates and sometimes adapted the countercultural politics of avant-garde art, whether in *The Twilight Zone*'s Surrealist take on contemporary political themes or *The Ernie Kovacs Show*'s inventive critique of the medium itself. Other trailblazing programs, most notably the hourlong dramatic series *The Defenders* (CBS, 1961–65) and *Route 66* (CBS, 1960–64), approached questions of modern life conceptually. While neither series depended on the kind of formal invention typified by Rod Serling's and Kovacs's projects, they captured the sense of a culture and a nation in flux—"a time when a range of unconventional ideas and political challenges were open for treatment in popular entertainment."[7]

Television executives were themselves often enamored of avant-garde art William S. Paley, founder and president of the Columbia Broadcasting System and an avid art collector, joined the board of trustees of the Museum of Modern Art in 1937 and served on it for half a century. So convinced were CBS executives of the artistic and social potential of television that they proposed a quarterly scholarly journal devoted to the medium. While the journal did not come to fruition, in 1962, the network did publish an anthology on the impact of television on society and culture, its title

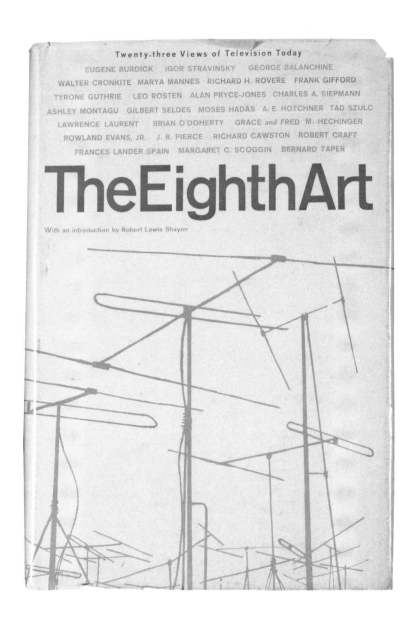

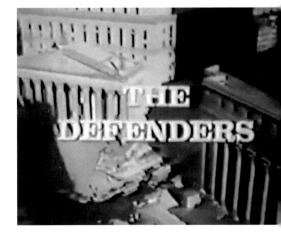

Eugene Burdick et al., *The Eighth Art:*
Twenty-Three Views of Television Today,
Holt, Rinehart and Winston, 1962.

Opening credits, *The Defenders*, CBS,
1961–65.

reflecting the network's aesthetic ambitions: *The Eighth Art*.[8] The book espoused a largely positive view of television, "the most vital of all living miracles," as one author referred to it.[9] One dialogue focused on Igor Stravinsky and George Balanchine's 1962 CBS teleplay *The Flood*, a ballet with music and words based on the biblical story of Noah. Despite misgivings about the project, Stravinsky continued to endorse television's artistic possibilities: "If I live to write another opera . . ." he concluded, "I know that it will be for the electronic glass tube, rather than for the early Baroque stages of the world's present-day opera houses."[10]

The pioneers of television understood its capacity, beyond its revolutionary technology, to alter and further modernize the look, feel, attitudes, and sensibility of contemporary life. This possibility inspired them, in turn, to appropriate the style and concepts of diverse avant-garde movements, including the Bauhaus, Russian Constructivism, De Stijl, Dada, Surrealism, Abstract Expressionism, Fluxus, Pop Art, Minimalism, and Op Art. Television's fascination with the avant-garde was self-conscious and public: throughout the 1950s and 1960s, the subject of modern art was explored and debated on network cultural and public affairs programs, including *Camera Three* (CBS, 1956–79; PBS, 1979–80), *See It Now* (CBS, 1951–58), *Today* (NBC, 1952–present), and *Wisdom* (NBC, 1957–58). As Lynn Spigel observes, such programs "served a strategic purpose in persuading the nation that television was a form of respectable culture," a goal inherent in television's practices almost since its inception.[11]

To elucidate early television's modernist aspirations is not to suggest that what made it to the screen was universally artistic or consequential. A good deal of network programming was—and remains today—oblivious of these loftier ideals. For executives, producers, and sponsors, it was principally ratings and the pressure to turn a profit that drove programming decisions. With shows riddled by commercials, sometimes to the point of incoherence, television was not always conducive to artistic discernment. Game shows, at least those with little imagination or literacy, walked contestants through a maze of mindless tasks and challenges. Situation comedies typically relied on formulaic scripts, slapstick, and predictable plots. And most serialized dramas, rather than offering rich explorations of the human condition, resorted to stock characters and a false sense of mystery and suspense to keep viewers coming back week after week. Even television's appropriation of modernist aesthetics and sensibilities was, in many instances, superficial and unimaginative—from the listless, prepackaged fantasy of youth

rebellion in *The Mod Squad* (ABC, 1968–73) to the ludicrous antics of a family headed by a modernist architect father in *The Brady Bunch* (ABC, 1969–74).

But early television was not simply the arid "wasteland" that the Federal Communications Commission chairman, Newton N. Minow, declared it to be in a speech to the National Association of Broadcasters in 1961.[12] Whether under the auspices of the networks or within the system of local educational television stations that emerged in the 1950s and 1960s, the industry was also fertile ground for high-quality programming and aesthetic and conceptual experimentation. In the end, the medium benefited from its early relationship with high art. This association was neither unique nor unusual. As the art historian Thomas Crow observes, the avant-garde was a source of influence and inspiration for popular culture from the mid-1800s on, "a kind of research and development arm of the culture industry."[13] By the early twentieth century, its impact was pervasive in sports, fashion, advertising, and entertainment. By the 1950s, the art historian William Sener Rusk, writing about the infiltration of modernist principles of abstraction and visual perception into everyday life, affirmed the public's increasing level of comfort with the avant-garde movements of earlier decades.[14]

In retrospect, television can also be seen to have influenced art, and culture in general, in ways that later transformed them. If the avant-garde, before the birth of television, was coextensive with modernism, some of its most adventurous practitioners, typified by Andy Warhol, began to look to the new medium for ideas and inspiration. The question of influence is complex: just as early television was driven by modernist thought and aesthetics, it helped inspire original vanguard art in its own right. This art, which welcomed television technology and even adapted its conceptual strategies—including fragmentation, appropriation, nostalgia, pastiche, and irony—has come to be associated with postmodernism. Thus, television not only was informed by the avant-garde but also inspired it, influencing a generation of visual artists committed to questioning its motives or transcending its limitations.

At its best, the interchange between trailblazing art and early television was neither simplistic nor cursory. *Revolution of the Eye* explores this aesthetic, conceptual, cultural, and political synergy through fine art and graphic design, ephemera, television memorabilia, and examples from film and television. More than just telling an entertaining story, it shines a light on the history of the visual revolution ushered in by American television and modernist art and design of the 1950s and 1960s.

THE TWILIGHT ZONE

ZONE

SURREALISM
FOR
THE MASSES

There is a fifth
dimension beyond
that which is known to
man. It is a dimension
as vast as space
and as timeless as
infinity. It is the middle
ground between
light and shadow,
between science and
superstition, and it lies
between the pit of man's
fears and the summit
of his knowledge.
This is the dimension
of imagination. It is an
area which we call . . .
the Twilight Zone.

Opening narration,
The Twilight Zone,
season one

The Twilight Zone, which premiered on CBS in October 1959, represents one of
the most sophisticated efforts to blend the ideas and imagery of the avant-garde
with fictional television. The half-hour dramatic series was created by Rod Serling,
acclaimed for his socially conscious scripts for *Playhouse 90* (CBS, 1956–60), *The
United States Steel Hour* (ABC, 1953–55; CBS, 1955–63), and *Kraft Television Theatre*
(NBC, 1947–58). The politically liberal Serling was known as the "angry young man"
of television's golden age, a reputation born of his repeated clashes with television
executives and sponsors over their attempts to censor or mitigate the political
content of his work.[15] His piercing teleplay *Noon on Doomsday*, produced for the
Steel Hour in 1956—a thinly veiled retelling of the racial murder of fourteen-year-
old Emmett Till in Mississippi a year earlier and the miscarriage of justice that
ensued—was toned down by the network, its victim transformed into a generic white
foreigner in a New England town. Frustrated with the commercialism of television,
and its timidity around controversial topics, Serling set out to create *The Twilight
Zone*. The innovative dramatic series took on the most important cultural and social
issues of the day.

Serling maintained strict artistic control over the program, writing or cowriting
an astonishing 92 of its 156 episodes. His scripts were literary and eloquent—poetic
without being self-conscious, as the actor Dan Duryea once noted.[16] The writer
Ayn Rand praised the show's dialogue as "some of the most beautiful . . . that has
ever issued forth from the mouths of TV characters."[17] While *The Twilight Zone*

was influenced by the traditional genres of fantasy, horror, and science fiction, it surpasses any one category. Exquisitely filmed in black-and-white, it combines science and the occult, the natural and the supernatural, into morally questioning essays about the nature of life in the nuclear age.[18] The artist Arlen Schumer notes that while the series featured scripts by prominent science fiction writers such as Richard Matheson, Charles Beaumont, and George Clayton Johnson, it cannot be "wholly considered a science fiction television series."[19]

"Everybody misses the point of what *Twilight Zone* was," Schumer observes. "Yes, there were elements of science fiction. Yes, there were elements of fantasy, even horror. But the show was straight from Surrealism, from [André] Breton's 'dimension of imagination.' "[20] Surrealist art and ideas provided Serling with a conceptual and aesthetic framework for exploring a range of philosophical matters, from the metaphorical to the political. The voiceover for the opening sequence of the first seasons, cited in the epigraph to this section, draws from the concepts and literary style of Breton's "Second Manifesto of Surrealism": "Everything leads us to believe," Breton wrote, "that there exists a spot in the mind from which life and death, the real and the imaginary, the past and the future, the high and the low, the communicable and the incommunicable will cease to appear contradictory."[21]

Breton's "spot in the mind," the principal realm of Surrealism, was rebranded by Serling as the zone of twilight. Schumer concludes: "He put surrealism on television."[22] Or, as George Clayton Johnson described them, the program's scripts were, "in a word, surreal. As an art form, surrealism tries to banish the distinction between the real and the unreal to provide an infinite expansion of reality. When Serling created *The Twilight Zone* . . . he took a job working on the frontiers of the timeless, searching for a foolproof unity of opposites."[23] The series relies on an array of Surrealist tropes, from its emphasis on states of madness and disassociation and its fascination with state-of-the-art or futuristic technologies to its synthesis of opposites, "the bringing together of two realities which are more or less remote," to quote the Surrealist poet Pierre Reverdy.[24] It reverberates as well with themes recurrent in Surrealist art—the eyeball, the whirling vortex, the mannequin, the door, the clock—including direct allusions to Salvador Dalí's *The Persistence of Memory* (1931), Marcel Duchamp's *Rotoreliefs* (1935) and *The Large Glass* (1915–23), and René Magritte's *The Victory* (1939) in the opening credits of seasons one, three, and four, respectively.[25]

PREVIOUS AND ABOVE
Stills from title sequence for *The Twilight Zone*, CBS, season three, 1959–61.

OVERLEAF
Marcel Duchamp, *Rotoreliefs (Optical Disks)*, 1935/1953. Offset lithography on paper, each disk 7 ⅞ in. diameter (20 cm). Musée National d'Art Moderne, Centre Georges Pompidou, Paris.

Modern Art and the Birth of American Television 15

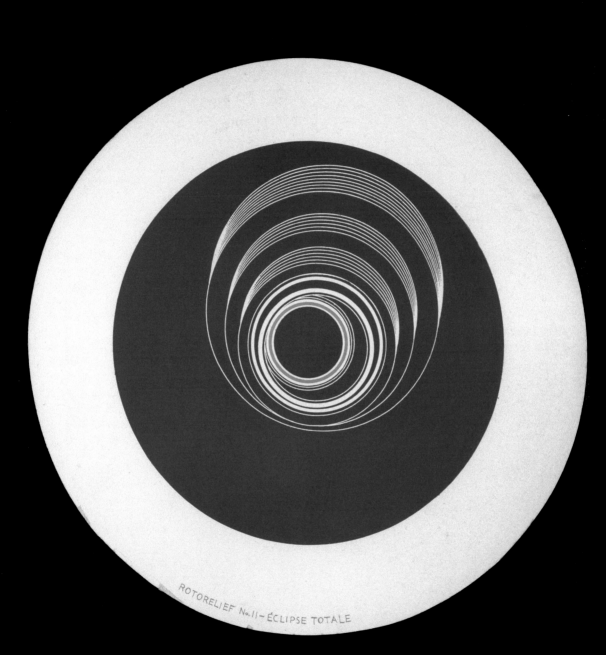

ROTORELIEF No.11 – ÉCLIPSE TOTALE

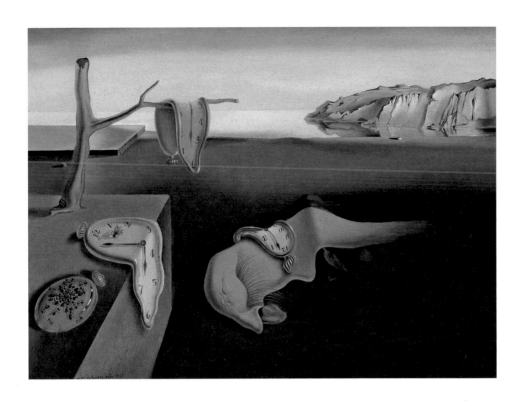

Salvador Dalí, *The Persistence of Memory*,
1931. Oil on canvas, 9 ½ × 13 in. (24.1 ×
33 cm). The Museum of Modern Art,
New York.

Still from title sequence, *The Twilight Zone*,
season one, 1959.

Marcel Duchamp, *The Bride Stripped Bare by Her Bachelors, Even (The Large Glass)*, 1915–23. Oil, varnish, lead, foil, lead wire, and dust on two glass panels, 109 ¼ × 70 × 3 ⅜ in. (277.5 × 177.8 × 8.6 cm). Philadelphia Museum of Art. Bequest of Katherine S. Dreier.

Still from title sequence, *The Twilight Zone*, season four, 1963.

The program's Surrealist references extend to its title. As the art historian Therese Lichtenstein notes, the concept of "twilight" is central to Surrealist art and thought:

> The term *twilight* operates here both literally and metaphorically; it represents an indeterminate time and space between day and night where objects and people are strangely illuminated and things are both revealed and concealed; it also describes an intellectual project that seeks to blur clear distinctions between dualities such as reality and fantasy, the conscious and the unconscious, subjectivity and objectivity, intellect and emotion, nature and culture, the grotesque and the beautiful, and high art and popular culture.[26]

Such dualities permeate the visual and conceptual space of *The Twilight Zone*, both in its provocative scripts and in its appropriation of the formal and stylistic devices of Surrealist film and photography—for instance, shooting from unconventional or oblique angles and focusing on odd or provocative details. The program creates an imaginary realm suspended between the conscious and the subconscious, between the mundane and the extraordinary, "a middle ground between light and shadow, between science and superstition," as Serling himself described it. And, like Surrealism, *The Twilight Zone* employs these effects to comment on a world in flux, a world in a period of "tumultuous social and cultural transformations."[27]

In its five seasons, the series explored multiple political issues. "Judgment Night" and "Deaths-Head Revisited" looked at the Holocaust and the flaws in human nature that would allow it to happen again. "The Eye of the Beholder" investigated the racial

OPPOSITE
René Magritte, *The Victory*, 1939.
Oil on canvas, 28 ½ × 21 ⅛ in. (73 × 54 cm).
Private collection.

RIGHT
Still from title sequence, *The Twilight Zone*,
season four, 1963.

and ethnic prejudices that underlie standards of beauty. "Third from the Sun," based on a short story by Richard Matheson, imagined a pending nuclear apocalypse and the human foibles that made it possible. "The Monsters Are Due on Maple Street" took aim at xenophobia, McCarthyism, and the herd mentality of the Cold War. "The Old Man in the Cave," set in a nation devastated by nuclear war, was a cautionary tale about greed and materialism. And "Number 12 Looks Just like You," which envisioned a "futuristic society where everyone is surgically altered to resemble fashion models," questioned the role of conformity in a ruthlessly corporate society.[28]

As the film critic J. Hoberman observes, *The Twilight Zone* was "one of America's few means for thinking about the unthinkable."[29] Trapped in a multitude of existential nightmares, its characters lived in a perpetual crisis of identity, fueled by a world that was often at the precipice of extinction. Such fantasies were never far from the minds of viewers, caught up in Cold War hysteria and gripped by the fear of nuclear annihilation. The program was "rife with sympathetic portrayals of dreamers and dropouts," antiestablishment heroes who challenged a reality that most Americans accepted without doubt.[30] The Surrealists, too, were attracted to and identified with cultural outcasts and others who questioned the conformity of the bourgeoisie.[31] Overtly critical of the disintegration of individualism, and resonating "with kindred motifs—doppelgängers, nightmares, malignant objects," *The Twilight Zone* exhibited "a profound, anxious preoccupation with the nature of the self."[32] Serling saw the program in opposition to a regressive and dangerous status quo, extolling individual choice and fruition as the greatest hope for avoiding its perils.

Still from "The Eye of the Beholder,"
The Twilight Zone, season two, 1960.

René Magritte, *The Lovers*, 1928. Oil on
canvas, 21 ⅜ x 28 ⅞ in. (54 × 73.4 cm).
The Museum of Modern Art, New York.

Stills from episodes of *The Twilight Zone*, CBS.

RIGHT, TOP TO BOTTOM
"Judgment Night," 1959; "Number 12 Looks Just Like You," 1964; "The Old Man in the Cave," 1963; "Deaths-Head Revisited," 1961.

BELOW
"The Monsters Are Due on Maple Street" and "Third from the Sun," 1960.

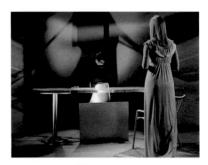

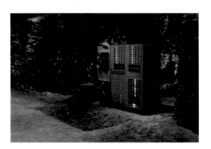

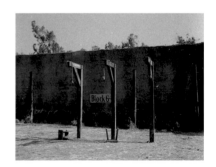

The Twilight Zone was, of course, a cultural product of its time, its psychological and existential themes compatible with those of the postwar avant-garde. The intellectual preoccupations of the abstract artists of the New York School, for example, represented a trenchant shift from those of earlier progressive art, from the overtly political, socialistic, or agitprop demands of the 1930s to notions of subjectivity, psychology, and the ethics of the self that came to dominate American culture in the 1950s and early 1960s. During this time, the arbiters and critics of high art—from the American Surrealist journals *View* (1940–47) and *VVV* (1942–44) to the critic Harold Rosenberg, with his advocacy of a process-oriented art of "action"—encouraged work that plumbed the unconscious, emphasized self-expression, or entailed existential themes.[33]

Much like the avant-garde that influenced it, *The Twilight Zone* reimagined the world in ways that were at once aesthetically inventive and politically progressive. The series proved to be "more than an oasis in a wasteland," as Hoberman notes.[34] "At best, it infused network television with a surprising degree of moral ambiguity; perhaps its greatest legacy was the sense of skepticism it inspired in its viewers."[35] This sense of skepticism—and irony—was not without artistic precedent; it was rather a rechanneling of aesthetic ideas and ideals through the lens of a new medium, a Surrealism for, and about, the masses.

Jean Fautrier, *Hostages on Black Ground*, 1946, printed c. 1960–64. Etching on paper, 14 ½ × 20 ½ in. (36.8 × 52.1 cm). The Jewish Museum, New York. Gift of Alex Schmelzer and Lisa Rotmil.

Begun during World War II, Jean Fautrier's *Hostage* images commented on a world scarred by prejudice, oppression, and conflict. They depict the victims of torture and war as eerie, generalized icons—a surreal, metaphoric approach also favored by Rod Serling in *The Twilight Zone*.

Herbert Ferber, *Surrational Zeus II*, 1947. Bronze, 50 ⅞ × 22 × 29 ½ in. (129.2 × 55.9 × 74.9 cm). The Jewish Museum, New York. Purchase: Leslie and Roslyn Goldstein Fund.

This sculpture typifies the mythic orientation of the artists of the New York School, working in an Abstract Expressionist mode. It conveys a fluid range of social and cultural associations —from the violent forces of war to otherworldly states of being.

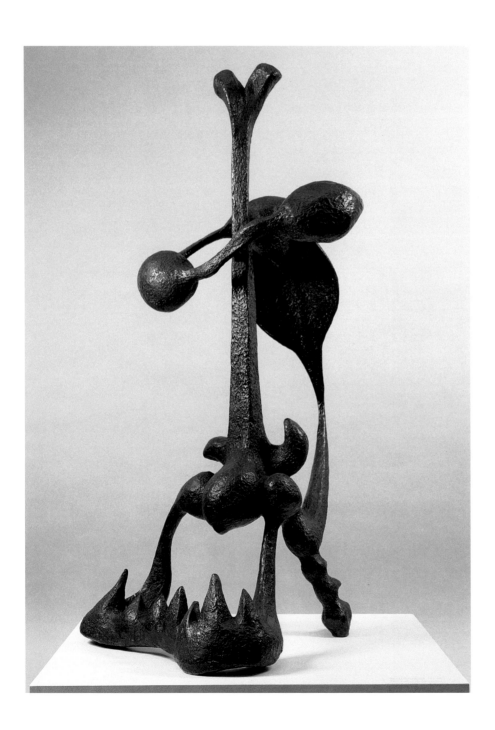

Joseph Breitenbach, *We New Yorkers*, 1942. Gelatin silver print and collage, 13 1/8 × 9 ¾ in. (33.3 × 24.8 cm). The Jewish Museum, New York. Purchase: Horace W. Goldsmith Foundation Fund.

We New Yorkers is one of Breitenbach's most profound Surrealist images. It explores and exemplifies the anxieties of postwar America, its eerie human presence a shimmering, ghostlike nervous system that hovers over an urban landscape. The themes of nuclear anxiety and urban alienation recur throughout the Surrealist imagery and iconography of *The Twilight Zone*.

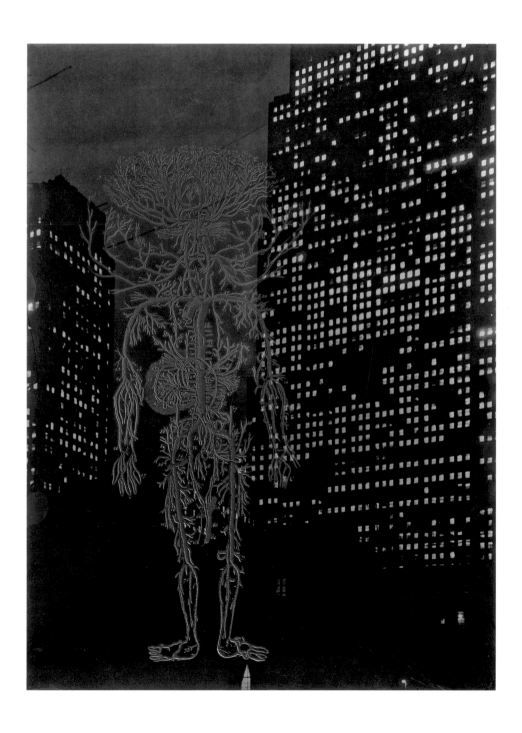

Still from Luis Buñuel and Salvador Dalí, *Un Chien Andalou (An Andalusian Dog)*, 1929.

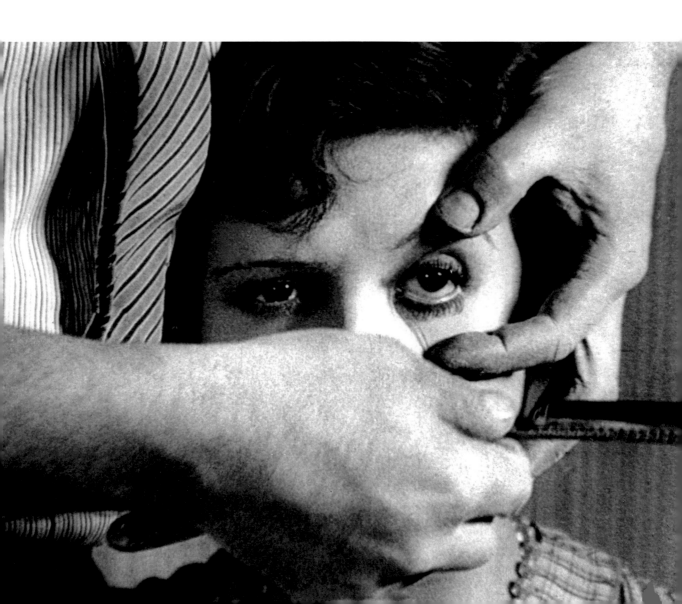

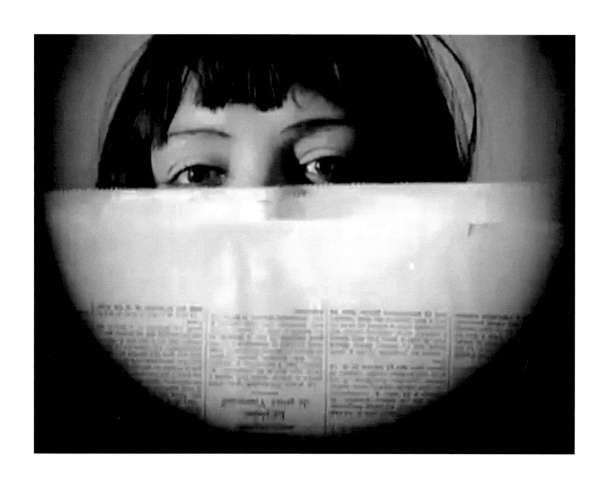

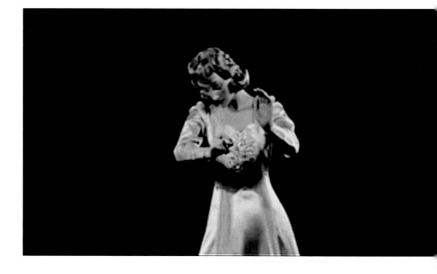

Man Ray, still from *L'Étoile de Mer (The Sea Star)*, 1928.

Surrealist films, formalistically innovative and representative of dreamlike or twilight states, embraced the social radicalism and anticonformist ambitions of the movement.

Fernand Léger, "The Girl with the Prefabricated Heart," still from a sequence in Hans Richter's film *Dreams That Money Can Buy*, 1947.

CBS: THE MODERNIST TELEVISION NETWORK

Under the twin impact of
the functionalism of the
Bauhaus and the practical
demands of American
business, the designer was
beginning to learn to use
the combination of word
and image to communicate
more effectively. Under the
influence of the modern
painters, he became more
aware (perhaps too aware)
of the textural qualities and
color values of type as an
element of design. . . .
I believe the designer won
his new status in the
business community
because he had demon-
strated that he could
communicate an idea or a
fact on the printed page at
least as well [as] and often
better than the writer, the
client, or his representative.

William Golden,
"Type Is to Read"

The design campaign at CBS was one of the most esteemed of any American corporation. Dr. Frank Stanton, president of the network from 1946 to 1971, fostered a highly controlled corporate image by establishing an in-house advertising and marketing division. He intrinsically understood one of television's most significant cultural attributes: its ability to enhance "the status of graphic design by promoting visual communication in popular culture."[36] The network's corporate identity was driven by sophisticated art directors, designers, and artists, including Saul Bass, Lou Dorfsman, William Golden, Georg Olden, Cipe Pineles, Ben Shahn, Paul Strand, Andy Warhol, and Kurt Weihs.[37]

The CBS design campaign was consistently influenced by modernist art and design—from the modified Didot typeface of the signage in the company's New York headquarters to the smart and elegant CBS eye trademark, inspired by the hex symbol on Shaker barns (page 35) and possibly Magritte's 1928 painting *The False Mirror*.[38] "The remarkable success of the CBS eye demonstrates why designers follow modernist principles in the first place," writes the designer Sagi Haviv. "In today's graphic tornado of complex, busy, and often disposable trademarks, the CBS eye stands as a beacon not only for the modernist ideal, but . . . for good design."[39] These ideals were also evident in two architectural commissions: the network's corporate headquarters in New York (opened in 1965)—known as "Black Rock," for its dark granite cladding—designed by Eero Saarinen, and CBS Television City in Los Angeles (1952), a sleek studio complex that reflected the bold, corporate point of view of

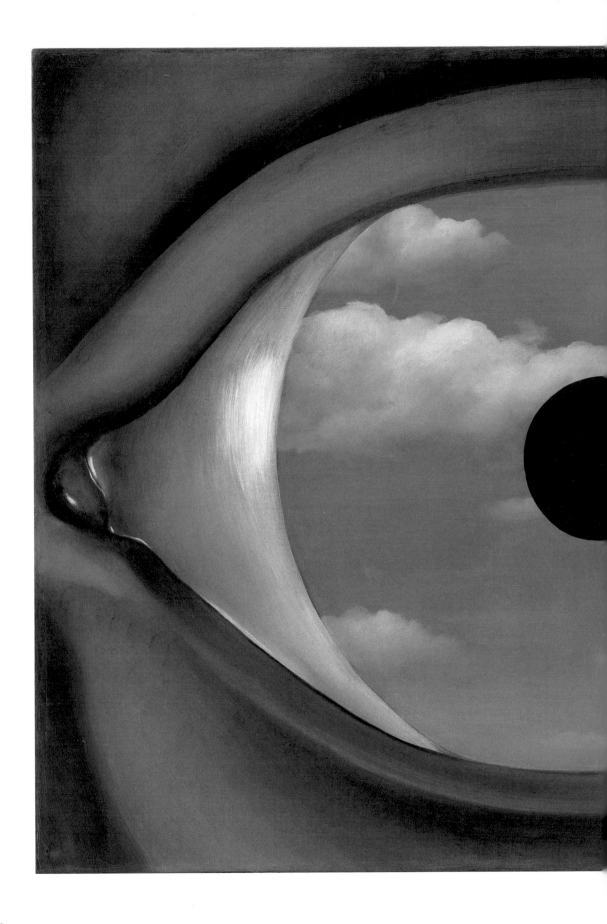

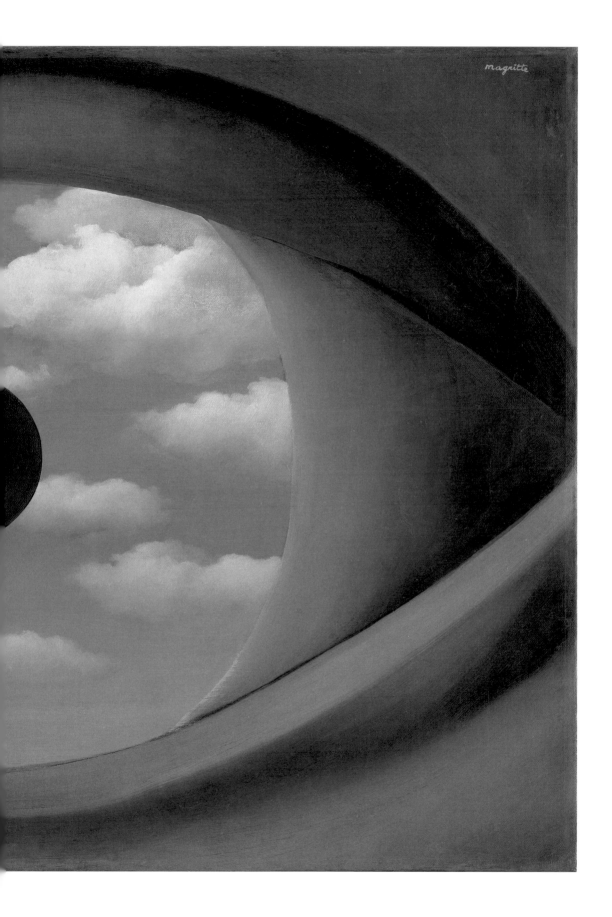

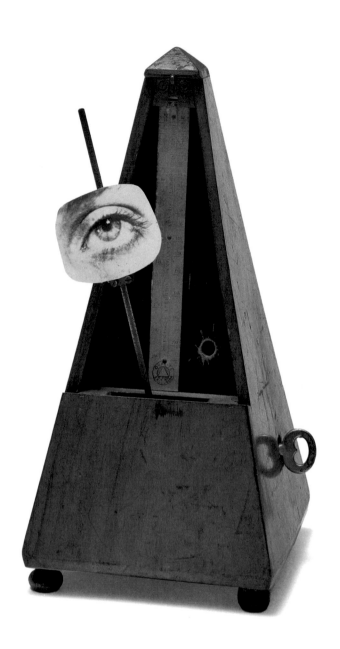

PREVIOUS
René Magritte, *The False Mirror*, 1928. Oil on canvas, 21 ¼ × 31 ⅞ in. (54 × 80.9 cm). The Museum of Modern Art, New York.

LEFT
Man Ray, *Indestructible Object (or Object to Be Destroyed)*, 1964 (replica of 1923 original). Metronome with cutout photograph of eye on pendulum, 8 ⅞ × 4 ⅜ × 4 ⅝ in. (22.5 × 11 × 11 cm). The Museum of Modern Art, New York.

OPPOSITE, TOP
"The Sign of Good Television," December 1951. Print advertisement, *Fortune* magazine.

OPPOSITE, BOTTOM
"The Gift to Be Simple," *Portfolio* 1, no. 1 (1950).

William Golden, CBS's art director, acknowledged only one source for the famous eye logo: the "evil eye" symbol on Shaker barns, which he had seen in this 1950 article.

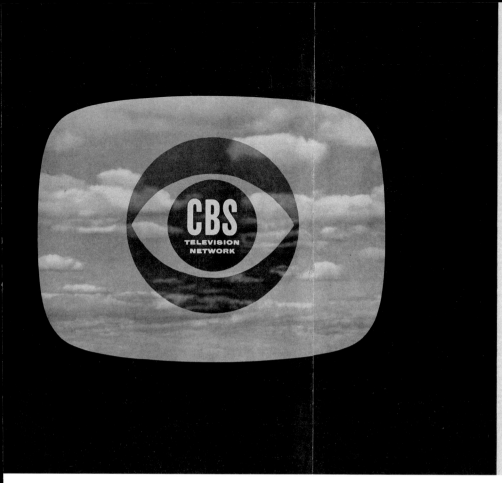

The sign
of good
television

When this symbol shines out from a
television screen, it identifies, for viewers
and advertisers alike, the network where
they're most likely to find what they're
looking for:

...where 6 of television's 10 most popular
shows* are broadcast

...where average ratings are higher than
on any other network*

...where television's solid-success package
programs come from...shows like Mama,
Toast of the Town, Studio One, Suspense,
Burns & Allen, Talent Scouts

...where the new hits will *keep* coming from:
I Love Lucy, Frank Sinatra, Corliss Archer,
See It Now, An Affair of State, Out There,
My Friend Irma

...where 59 national advertisers...including
15 of America's 20 biggest...are profitably
doing business today.**

"This is the CBS Television Network"

*Trendex TV Program Popularity Report October 1-7
**October 15

LEFT AND BELOW
CBS ashtrays, c. 1966, c. 1952, and c. 1955.
Glass. Private collection.

OPPOSITE
Together with Music, 1955. Vinyl record.
Private collection.

The CBS eye, established in 1951 and still
in use, is a famous and widely admired
corporate trademark. It was employed
by both the national network and local
affiliates and adorned everything from the
skyscraper headquarters to ashtrays. The
eye was an important symbol in Surrealism,
as seen in Man Ray's *Indestructible Object*
(or *Object to Be Destroyed*) and Magritte's
The False Mirror.

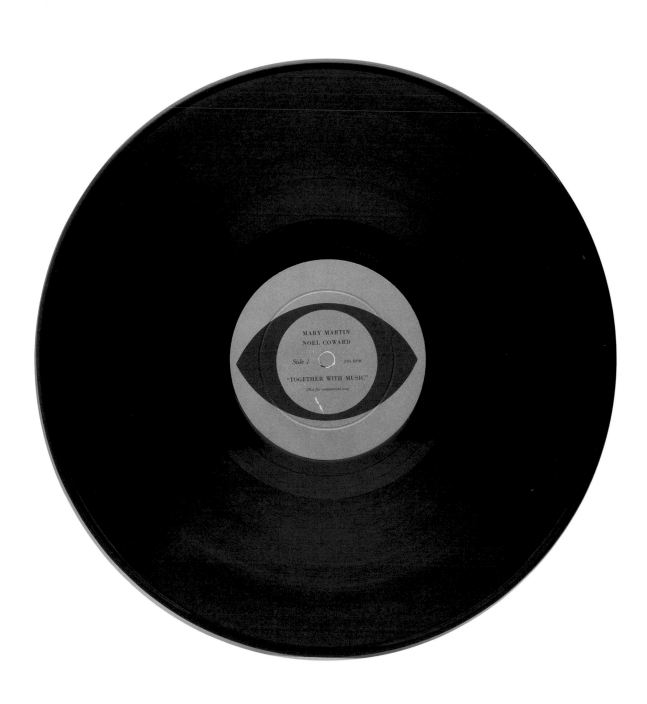

Charles Luckman, an advertising executive and "Boy Wonder of American Business" turned architect, and his partner, William Pereira.[40]

If the corporate image of the "Tiffany network"—as CBS was known, for its aesthetic discernment and quality programming—attempted to unite the best of modern design with the dynamism of the new medium of television, it also reflected the social and cultural politics of its designers (and of the executives who supported them). William Golden, CBS Television's legendary art director from 1937 until his death in 1959, and chief architect of its corporate identity, for instance, favored humanist and socially conscious representational imagery.[41] Although he supported abstraction in design—epitomized by the CBS eye—Golden criticized abstract art. He found such work, especially Abstract Expressionism, the foremost movement of the New York School, self-indulgent to the point of "saying nothing and saying it with considerable facility."[42] He believed that good design was less about self-expression and the approval of other designers, and more about inspiring interest in the network and its programming. As Golden observed:

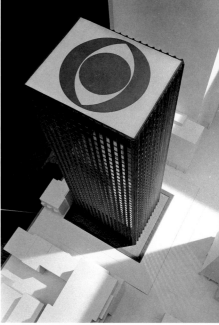

OPPOSITE
CBS Television City, Los Angeles, c. early
1950s. Photographed by Ezra Stoller.

ABOVE AND RIGHT
Eero Saarinen (architect), CBS corporate
headquarters, New York, c. 1960–62.
Scale model. Photographed by Bill Maris.
Collection Yale University Art Gallery.

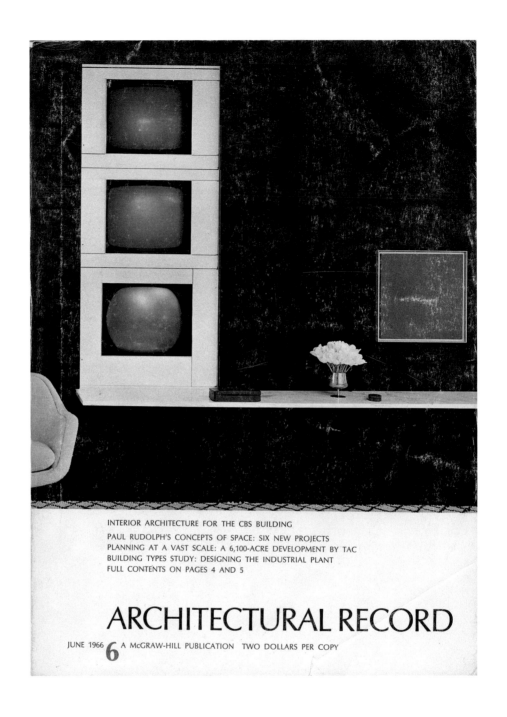

INTERIOR ARCHITECTURE FOR THE CBS BUILDING
PAUL RUDOLPH'S CONCEPTS OF SPACE: SIX NEW PROJECTS
PLANNING AT A VAST SCALE: A 6,100-ACRE DEVELOPMENT BY TAC
BUILDING TYPES STUDY: DESIGNING THE INDUSTRIAL PLANT
FULL CONTENTS ON PAGES 4 AND 5

ARCHITECTURAL RECORD

JUNE 1966 **6** A McGRAW-HILL PUBLICATION TWO DOLLARS PER COPY

Cover, *Architectural Record*, June 1966,
showing the celebrated modernist interior
design of CBS's New York corporate
headquarters.

To regard the blank rectangle on a layout pad with the same attitude that the abstract painter confronts his blank canvas is surely a pointless delusion. . . . A graphic designer is employed, for a certain sum of money, by someone who wants to say something in print to somebody. The man with something to say comes to the designer in the belief that the designer with his special skills will say it more effectively for him.[43]

While deferential to corporate interests and the need to sell a product, Golden rejected pure abstraction for another reason as well: he conceived of advertising as a vessel for ideas. His advocacy of abstract form in design and social realism—he repeatedly commissioned his friend Ben Shahn, among the most politically outspoken artists of his time—suggests an ideological dimension to his work, one that was nevertheless "compatible with the corporate, technocratic, and paternalistic ideals of postwar Western mass societies."[44] By 1958, frustrated by what he believed was the unethical encroachment of network actors, writers, directors, and producers on the design process, Golden charged that advertising campaigns too often satisfied "only a contractual commitment" that "benefited neither the programs, the stars, nor the interests of CBS television."[45]

Golden's CBS colleague Georg Olden, the director of graphic design and one of the first African Americans to hold an executive position at a network, was an ardent champion of contemporary art. He joined the network in 1945, commissioning on-

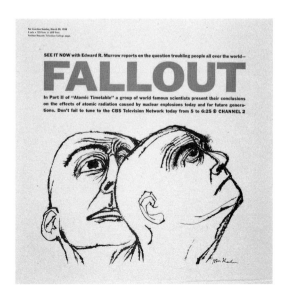

Ben Shahn, *Fallout*, 1958. Lithograph on paper, 11 ¼ × 11 ⅜ in. (28.6 × 28.8 cm). The Jewish Museum, New York. Gift of Dolores S. Taller in Memory of Stephen Lee Taller.

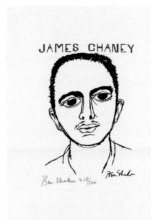

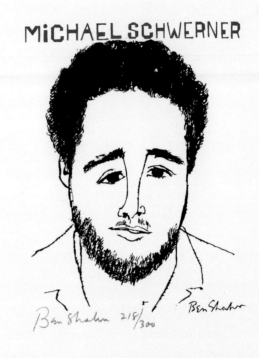

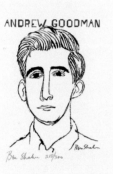

Ben Shahn, *James Chaney, Andrew
Goodman, Michael Schwerner*, 1965.
Screenprint on paper, each 21 ⅞ × 16 ¾ in.
(55.6 × 42.5 cm). The Jewish Museum,
New York. Purchase: Kristie A. Jayne Fund.

Ben Shahn, "The Big Push," 1960. Print
advertisement, *Fortune* magazine.

Ben Shahn's modernist illustrations and
graphic design are instantly recognizable
by the use of a thin, highly activated line.
Equally distinctive are his artworks infused
with progressive ideals. His portraits of
three young civil rights workers murdered
by the Ku Klux Klan in 1964 commemorate
a key moment in American racial politics.

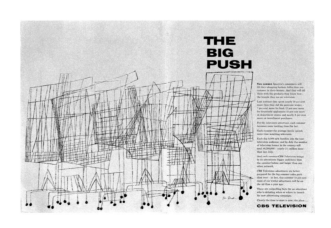

air art and title cards by modern artists that made a significant impact on American graphic design. "The door is open for artists on TV," Olden proclaimed in a 1954 *American Artist* magazine profile about his hiring of such well-established modernist artists as Edward Chavez, Antonio Frasconi, Richard Lindner, and Andy Warhol.[46]

Lou Dorfsman, who succeeded Golden as the network's creative director for advertising and design, began his tenure at CBS in 1946 as a graphic designer. By the time he retired in 1987, he had "left his mark on virtually every aspect of the organization, from the design of the letterhead and covers for annual reports to advertising graphics and office interiors."[47] His graphic campaign for CBS's new headquarters, which involved everything from signage to the paper cups and plates used in its cafeteria, was, like the rest of his work in general, visually dynamic, provocative, and conceptually complex. It was also audience-friendly.

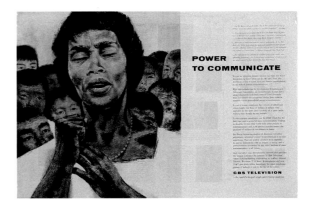

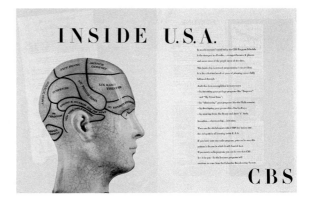

William Golden (art director), CBS corporate advertisements, 1948–59. *Fortune* magazine.

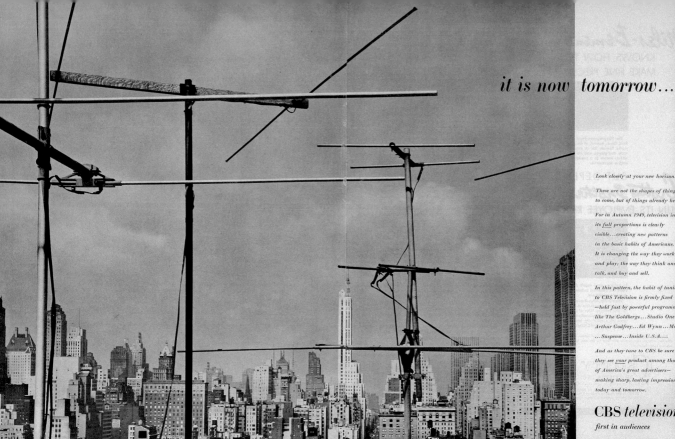

it is now tomorrow...

Look closely at your new horizon.

These are not the shapes of things
to come, but of things already here.

For in Autumn 1949, television in
its *full* proportions is clearly
visible...creating new patterns
in the basic habits of Americans.
It is changing the way they work
and play; the way they think and
talk, and buy and sell.

In this pattern, the habit of tuning
to CBS Television is firmly fixed
—held fast by powerful programs
like The Goldbergs...Studio One...
Arthur Godfrey...Ed Wynn...Mc
...Suspense...Inside U.S.A....

And as they tune to CBS be sure
they see *your* product among those
of America's great advertisers—
making sharp, lasting impressions
today and tomorrow.

CBS television

first in audiences

THESE PAGES AND OVERLEAF
William Golden (art director), CBS
corporate advertisements, 1948–59.
Fortune magazine.

44

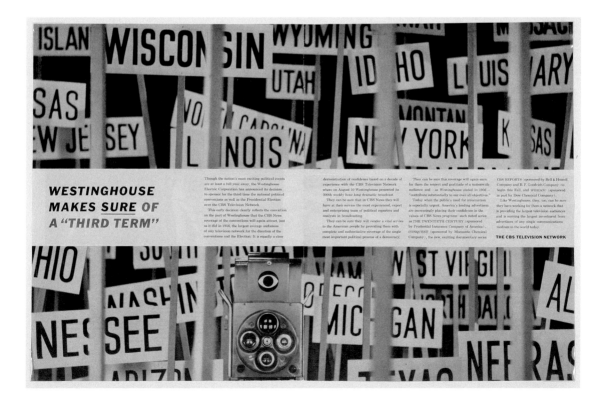

David Stone Martin

man is
dangerous

He's got to like what he sees, or he'll turn you off.

With advertisers, too, programs come first.

In the eight cities where more than
half the television audience is, CBS
programs are first*...with 6 of the 10
most popular shows—all CBS-created—
winning for advertisers television's
largest average audiences.

Turn first to CBS...
because CBS has most of the programs
most of your customers want.

CBS·TV

*February 1950, 8-City Pulse Ratings:
New York, Philadelphia, Chicago,
Boston, Cincinnati, Washington,
Los Angeles, Cleveland.

—first in programs

"...the only newscaster who uses the medium in a dramatic, imaginative way..." *WALTER WINCHELL, N. Y. DAILY MIRROR*

"...lifting the medium to a new high in maturity and usefulness..." *JACK GOULD, N. Y. TIMES*

"...will revive the old-fashioned American custom of passing Sunday afternoons at home..." *HY GARDNER, N. Y. HERALD TRIBUNE*

"...comes closest to the ideal of video journalism..." *EDITOR & PUBLISHER*

"...the best program of its kind that I have ever watched..." *HARRIET VAN HORNE, N. Y. WORLD-TELEGRAM & SUN*

"...television's best and liveliest news show..." *TIME*

"...at once fascinating and provocative...a maximum flair for showmanship..." *VARIETY*

"...nothing short of spectacular..." *PHILIP HAMBURGER, THE NEW YORKER*

"...destined to be one of the top news documentaries of our time..." *RADIO DAILY*

AMBASSADOR FOR TELEVISION

Just when you think television has settled into a predictable pattern, along comes a program like "See It Now"...one that jolts critics and broadcasters into acknowledging that television's horizons have barely been sighted.

This program quite simply and logically offers a *television* solution to a particular problem—reporting and interpreting the news.

To Edward R. Murrow, and his co-producer, Fred W. Friendly, we add our own applause to that of the critics. And to the sponsor, Alcoa, our congratulations for enlisting an ambassador so welcome in American homes.

To other advertisers, we offer this important footnote: even a program so brilliantly conceived and edited as this, needs the painstaking production skill and polish CBS Television provides for all its wide range of programs.

Today CBS Television crackles with new program activity, shaping shows to provide the kind of television 1952 advertisers need.

The program that will most effectively represent you to your public is most likely to be found where "See It Now" was produced.

CBS TELEVISION

RRTBouché.

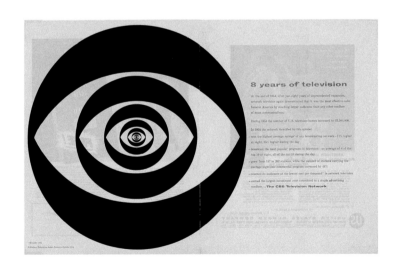

8 years of television

At the end of 1954, after just eight years of unprecedented expansion, network television again demonstrated that it was the most effective sales force in America by reaching larger audiences than any other medium of mass communications.

During 1954 the number of U.S. television homes increased to 32,500,000.

In 1954 the network electrified this symbol

- won the highest average ratings of any broadcasting network—11% higher at night, 45% higher during the day
- broadcast the most popular programs in television—an average of 6 of the top 10 at night, all of the top 10 during the day
- grew from 157 to 202 stations, while the number of stations carrying the average nighttime commercial program increased by 44%
- reached its audience at the lowest cost per thousand in network television
- earned the largest investment ever committed to a single advertising medium...The CBS Television Network

OPPOSITE AND ABOVE
William Golden (art director), CBS corporate advertisements, 1948–59. *Fortune* magazine.

RIGHT
Lou Dorfsman (designer), print advertisement for the CBS series *Of Black America*, 1968. The Herb Lubalin Study Center of Design and Typography, the Cooper Union, New York.

While Black Rock was under construction, Dorfsman organized interactive exhibitions in a pedestrian walkway, animating the dreary space and attracting passersby. (page 52).[48] Dorfsman's print work was equally adventurous and lucid, typified by the jacket of a book commemorating the 1969 moon landing, its embossed paper imitating the lunar surface (page 53), and by the haunting advertisement for the news series *Of Black America* (1968, page 49), "an icon of design history."[49] More than any other single designer, Dorfsman established the visual identity of CBS, maintaining the "consistently high quality of graphic and industrial design throughout the company."[50]

CBS was not alone in its aesthetic ambitions. Executives at the National Broadcasting Company were similarly disposed toward innovative art and design. In 1951, its president, Sylvester "Pat" Weaver, organized Operation Frontal Lobes, to introduce the latest art and science to a wide national audience. The broadcasts associated with this initiative, intended in part to enhance the network's public image, were aired without commercials. Several years later, John J. Graham— abstract painter, Pablo Picasso devotee, and early champion of Andy Warhol's commercial work—was appointed art director for advertising and promotion at NBC.[51] He advanced the idea that abstract and colorful animations, such as the network's unfurling peacock logo, could better capture the attention of viewers.

Not to be outdone, the American Broadcasting Company commissioned Paul Rand—whose 1947 book *Thoughts on Design* had had a significant impact on advertising, print, and broadcast graphic design—to rethink its corporate campaign in the early 1960s.[52] Experimenting with letterforms that would remain readable even with poor television reception, Rand designed ABC's trendsetting minimalist logo, in use to the present day (page 136).

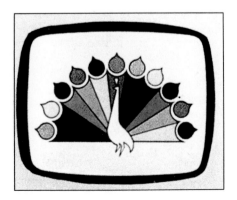

John J. Graham (art director), NBC logo, 1956. The Granger Collection, New York.

Richard Lindner, Edward Chavez, and
Antonio Frasconi (designers), on-air title
cards, *Studio One*, CBS, c. 1953–54.

Lou Dorfsman (designer), temporary
exhibition in walkway of CBS Building
construction site, New York, c. 1963–64.

OPPOSITE
Lou Dorfsman (designer), *10:56:20 PM EDT
7/20/69: The Historic Conquest of the
Moon as Reported to the American People
by CBS News over the CBS Television
Network*, Diane Publishing Company, 1970.
Private collection.

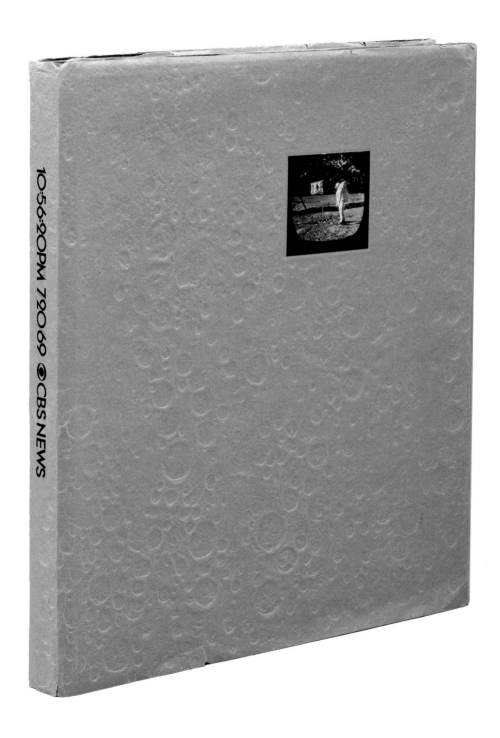

PREACHING THE GOSPEL

MODERNISM
ON
TELEVISION

We are past the panic
point . . . [when] the self-
styled intellectual elite
were wringing their hands
in despair over the
growing audience for the
arts. They insisted that
there was a Gresham's
law at work—that the bad
would push out the good,
that the good would
dislodge the excellent.
They wailed and moaned
over the coming demise
of High Culture. But
these snipings from
their ivory towers now
seem outdated. And just
plain silly.

Aline Saarinen, "What
about the Cultural
Explosion?"

The imperative of the networks to exploit modern art and design as symbols of excellence was no doubt motivated by the principally negative view of mass culture advocated by public intellectuals of the period. Works by American writers of the 1950s—including David Riesman's *The Lonely Crowd* (1950), C. Wright Mills's *White Collar: The American Middle Classes* (1951), and William H. Whyte Jr.'s *The Organization Man* (1956)—argued that workers were little more than cogs in vast corporate bureaucracies, their leisure time shaped by a consumerist culture indifferent to human and aesthetic values. To counter this perception, popular cultural institutions, including the television networks, turned to modernist ideas, principles, and aesthetics to convey an image of nonconformity and discernment.

The relationship between the two was symbiotic: television also served as an authoritative and popular medium for disseminating ideas about modern art. As early as 1939, *Art in Our Time* (page 123), an exhibition celebrating the tenth anniversary of the Museum of Modern Art, was discussed in the first television broadcast by an American museum (produced in collaboration with NBC). The program extended the exhibition's reach and influence while adding a note of intellectual gravitas to the nascent medium.

By the mid-1960s, the work of Aline Saarinen for NBC News and *Today* helped make comprehensible to a vast audience modernist art, design, ideas, and institutions. Saarinen, born in New York in 1914, was the daughter of the businessman Allen Bernstein and his wife, Irma, both amateur painters. Taken on

European art tours as a child by her parents, Saarinen majored in art and English at Vassar, and was art critic for the college newspaper. She received her master's degree from New York University's Institute of Fine Arts. In 1944, she joined the staff of *ARTnews*, and two years later became its managing editor. In 1948, she was appointed associate art editor and critic at *The New York Times*; her writing there frequently examined the relationship between art and society. In 1963, Saarinen became the art and architecture editor and on-air critic for NBC's *Sunday* and *Today* shows—the first such appointment on an American television news program.[53]

Saarinen explored the work of art institutions as well as artists, designers, and architects, and interviewed many of them.[54] Filmed stylishly, often with the flair of French New Wave cinema, her presentations were lucid, urbane, informative, and critical; they introduced a generation of Americans to the art and architecture she supported. She also rebuffed work she found unexceptional—Mount Rushmore, Salvador Dalí's *Last Supper* (1955), and the Pan Am Building in New York. Saarinen believed that the appreciation of art was not limited to insiders and cultural elites.[55] She rejected the idea that bringing "other considerations . . . to the enjoyment of art was to vulgarize it," a view then advocated by formalist critics who shunned the discussion of the social or cultural contexts that influence and define art.[56]

Saarinen engaged television and the popular press—she wrote regularly for such magazines as *Vogue*, *McCall's*, and *TV Guide*—to educate the viewer or reader in order to "open his eyes wider and enable him to look more penetratingly."[57] Although she covered much of art history, she was particularly conversant with modern art and ideas; she published one of the earliest monographs on the African American painter Jacob Lawrence, and as a publicist for and advisor to the respected architect Eero Saarinen, whom she married in 1954, she helped promulgate the "Eero myth," as she put it, throughout popular culture.[58] She was also able to demystify modern art for millions of Americans, a subject avoided by many news organizations for its seeming obscurity and elitism.

This apprehension notwithstanding, almost from its inception television opened its doors to appearances by avant-garde artists. Beginning in the early 1950s and continuing well into the 1960s, scores of local and national network programs—as diverse as the weekly variety hour *The Ed Sullivan Show* (CBS, 1948–71), the quiz shows *What's My Line?* (CBS, 1950–67) and *I've Got a Secret* (CBS, 1952–67), and the cultural and political affairs series *Omnibus* (CBS, ABC, NBC, 1952–61), *USA Artists* (NET, 1966), and *See It Now* (CBS, 1951–58)—featured interviews with or demonstrations by Bruce Conner, Salvador Dalí, Alberto Giacometti,

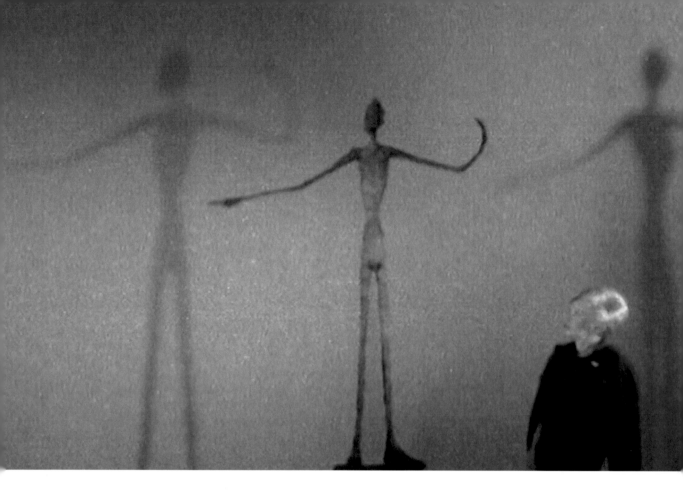

Aline Saarinen (host), still from "Alberto
Giacometti," *Sunday*, NBC, May 24, 1964.

The experimental composer John Cage
performing "Water Walk" on *I've Got a
Secret*, CBS, 1960.

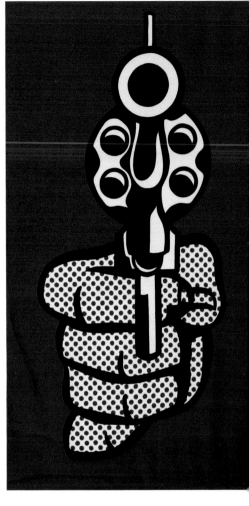

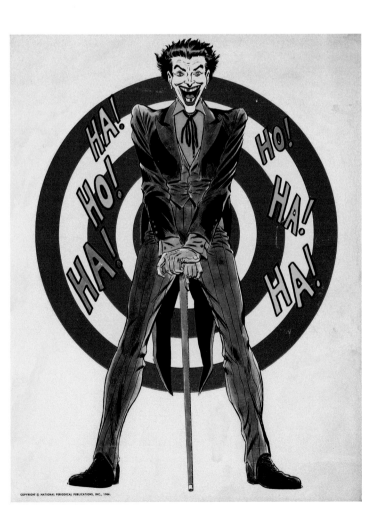

COPYRIGHT © NATIONAL PERIODICAL PUBLICATIONS, INC., 1966.

ABOVE
Roy Lichtenstein, *Pistol*, 1964.
Felt, 82 × 49 in. (208.3 × 124.4 cm).
The Museum of Modern Art, New York.

LEFT
"The Joker," c. 1966. Poster for the *Batman*
television program.

OPPOSITE
Stills from "Pop Goes the Joker," *Batman*,
ABC, 1967.

Stuart Davis, Marcel Duchamp, Ed Emshwiller, Allan Kaprow, Roy Lichtenstein, Barnett Newman, Georgia O'Keeffe, David Smith, Andy Warhol, and many other artists. And documentaries such as *The Responsive Eye* (CBS, 1965) and "Shots from the Underground" (CBS, 1966)—exploring Op Art and avant-garde film—brought complex ideas about vanguard art into the homes of millions of Americans.

The work of contemporary artists and designers also shaped the style and visual content of television. The avant-garde filmmaker Stan VanDerBeek, for example, was one of the animators of the children's program *Winky Dink and You* (CBS, 1953–57), television's first fully interactive show. On the program children were invited to send away for plastic screens and special crayons that allowed them to draw on the plastic, superimposed on their TV screens; young Americans were thus encouraged to mine the possibilities of visual art. Inspired by the imagery of Pop Art, the ABC series *Batman* (1966–68) centered on the exploits of the comic book heroes Batman and Robin as they defended Gotham City. This influence was not just stylistic: a two-part episode, "Pop Goes the Joker," depicted the city's art world, complete with a villain-*cum*-Conceptual artist who spray-paints conservative works of art, and his gullible patron, Baby Jane Towser, a transparent reference to Andy Warhol's wealthy muse Baby Jane Holzer.[59] The episodes also reveal television's contradictory relationship to modern art: even as *Batman* engaged the avant-garde to increase its own hipness quotient, the show ruthlessly satirized its presumed elitism.[60]

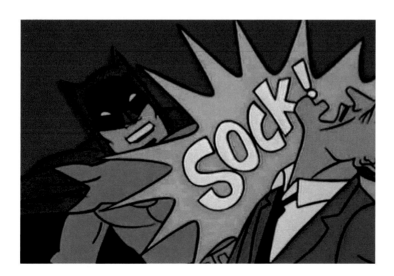

GAME ↑ WINDOW

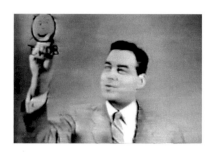

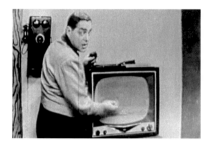

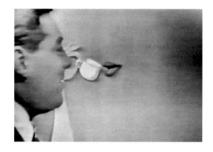

OPPOSITE
Winky Dink game book, c. 1954.

ABOVE
Stills from *Winky Dink and You*, CBS,
c. 1953–57.

RIGHT
Stan VanDerBeek, still from *A La Mode*,
1959. Black-and-white film.

VanDerBeek's avant-garde sensibility is
visible in his dynamic experimental films.

Variety series sometimes featured stage sets influenced by avant-garde art and design. In 1952 and 1953, episodes of *The Dinah Shore Show* (NBC, 1951–63) included set designs inspired by Alexander Calder, Raoul Dufy, Georgia O'Keeffe, Pablo Picasso, and other modern artists. "Painting and sculpture, usually confined to galleries or private collections," wrote *Look* magazine, "have been receiving attention on coast-to-coast television. . . . Art of this sort is being brought to a much wider audience."[61] Television stagecraft, rarely this elaborate, was usually far more minimal. In his book *Designing for TV*, the NBC art director Robert J. Wade wrote of the affinity of one of the most popular forms of contemporary television design—"skeletal sets," composed of spare, abstract structures and forms—with Russian Constructivism: "In essence, they are the outgrowth of one of the dogmas of modern stylization, which insists that form be defined in space mainly by plane or linear means, such as certain types of 'structural' architecture and of metal sculpture."[62] These sets, Wade believed, were particularly well suited to the variety format, "because they are clean lined, understandably impressionistic without being arty, very economical and capable of being extended or reduced for subsequent usage by deft manipulation of saw, hammer, or hatchet."[63]

Set design on variety programs also looked to contemporary art—especially by the mid-1960s, when the networks shifted to all-color formats—in ways that went beyond practicality and efficiency. Broadcast live, with no two sets the same, *The Ed Sullivan Show* adapted the look and sensibility of avant-garde movements, including Color Field painting, Minimalism, Op, Pop, and psychedelic art. The comedy-variety program *Rowan & Martin's Laugh-In* (NBC, 1968–73) was noted for its dynamic

RIGHT
Vsevolod Meyerhold's Russian
Constructivist stage set for Vladimir
Mayakovsky's *The Bathhouse*, 1930.

BELOW AND OPPOSITE
Stills from *The Dinah Shore Show*,
NBC, 1953.

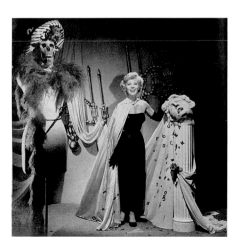

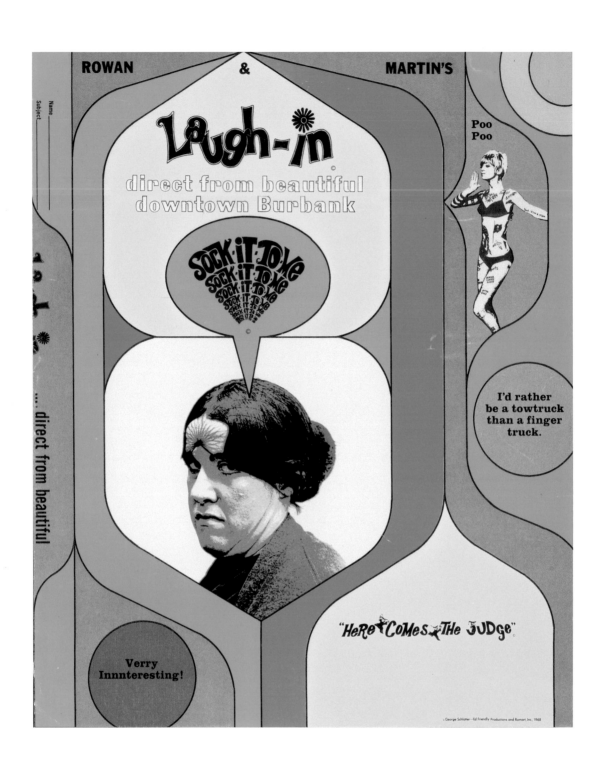

Rowan & Martin's Laugh-In book cover, 1968.

Pop, Op, and psychedelic sets. What these artistic movements had in common, and what may have made them attractive to set designers, was the way they altered the traditional contemplative and hierarchical relationship between viewers and art objects.

Pop Art, for instance, appropriated the style and content of mass culture, trafficking in imagery that, unlike the hermetic and cerebral content of modernist abstraction, was already a part of viewers' cultural space. Unlike most modernist painting and sculpture, which presented a reductive or abstracted view of the real world, Color Field painting, Op Art, and Minimalism eschewed references to external narratives or objects in order to make the experience of art as immediate as possible. Color Field painting and Op Art challenged spectators with sweeping fields of color or instantaneous and dizzying optical illusions. Fabricated from everyday industrial materials, presented in human scale, and devoid of pedestals, Minimalist sculpture erased the barrier between object and viewer. By distorting the gestalt of seemingly familiar elemental forms—sloping one side of a cube, say—or positioning them at

Still from *The Ed Sullivan Show*, with Gladys Knight and the Pips performing on a set influenced by psychedelic art.

The joke wall, *Rowan & Martin's Laugh-In*, NBC, 1968.

The vivid stagecraft of *Rowan & Martin's Laugh-In* resonates with a sixties aesthetic, drawing on influences ranging from the paintings of Andy Warhol to psychedelic rock music posters (page 72).

The Ed Sullivan Show, CBS, mid-1950s through 1971: sets often reflected the styles of avant-garde art, from Existentialist white staircases leading nowhere to oversize, abstract geometric forms. Backdrops, now in color, were sometimes eerie, empty landscapes reminiscent of Surrealism or borrowed from Minimalist and Color Field painting and Pop and Op Art.

Robert Morris, *Untitled (Battered Cubes)*, 1965. Latex paint on wood, dimensions variable. Private collection.

Sol LeWitt, *Serial Project, I (ABCD)*, 1966.
Baked enamel on steel units over baked
enamel on aluminum, 20 in. × 13 ft., 7 in.
× 13 ft., 7 in. (50.8 × 398.9 × 398.9 cm).
The Museum of Modern Art, New York.

Minimalist sculptures displayed in the
exhibition *Primary Structures*, 1966.
The Jewish Museum, New York.

BELOW

Larry Bell, *Leadbelly's Dance*, c. 1960–61. Acrylic on canvas, 64 ⅞ × 64 ⅞ in. (164.8 × 164.8 cm). Addison Gallery of American Art, gift of Frank Stella.

In the fifties and sixties Color Field painting influenced television set designs, notably *The Ed Sullivan Show* (page 66), inspiring the use of bold hues and geometric forms.

OVERLEAF

Yaacov Agam, *Paam*, 1969, seen from two different angles. Oil on aluminum mounted on wood board, 31 ⅞ × 73 ⅜ × 3 ¼ in. (81 × 186.4 × 8.3 cm). The Jewish Museum, New York. Gift of William Benenson.

Op Art and kinetic sculpture of the 1960s turned up in the sometimes frenetic designs of television shows, exploiting the wide availability of color broadcasting.

Bonnie MacLean, psychedelic poster for a concert featuring the Yardbirds, the Doors, and others, Fillmore Auditorium, San Francisco, July 25, 1967.

Stills from television commercials.

OPPOSITE, LEFT
Television commercial for Esso gasoline, 1957.

OPPOSITE, RIGHT
Television commercial for Kodak Instamatic cameras, c. 1965.

oblique angles, this sculpture could not be understood from a single point of view; it required sustained and direct interaction. In order to apprehend what they were seeing and experiencing, spectators were compelled to move around and even walk directly on, into, or through a sculpture.[64] Stage sets inspired by these artistic movements provided visually immediate backdrops, designed not to create old-style theatrical illusions of real-world spaces, but to foreground performers while also offering visual interest. Much like the art that influenced them, rather than summon viewers into imaginary realms, these sets rooted them in a fresh, energetic present, and accentuated the variety format's unique dependence on live performance or transmission.

Television commercials were also fertile ground for aesthetic invention, with sponsors and advertising agencies turning to modern art and graphic design for ideas. Indeed, the "New Advertising" revolution of the 1950s and 1960s resulted in one of the most creative periods of the medium in the United States. At their best, television spots—as brief as fifteen seconds, as long as a minute—were well crafted and seductive short films designed to sell a product by winning the attention and stoking the desire of viewers. Their indebtedness to avant-garde aesthetics, though not always noteworthy, is evident in many campaigns, from the "moderne" animation of a 1957 Esso gasoline commercial to the eye-popping visuals of an Op Art–inspired 1965 ad for Kodak Instamatic cameras. Perhaps no commercial director was more aesthetically sophisticated than Saul Bass. Among the foremost mid-twentieth-century American graphic designers, Bass was known for his bold corporate campaigns and title sequences for such films and television series as *The Man with the Golden Arm* (1955), *Vertigo* (1958), *Psycho* (1960), *Hallmark Hall of Fame* (NBC,

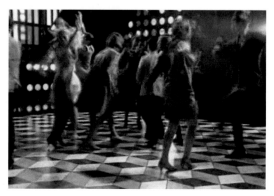

CBS, PBS, ABC, 1952–present), *Playhouse 90*, and *Profiles in Courage* (NBC, 1964–65). Bass's commercials for IBM ("History of Invention," 1962), Mennen ("Baby Magic," 1962), RCA ("The Kid," 1968), and other sponsors are less well-known but no less significant. "I feel there is more than one way to do a selling job," Bass observed about the high standards he brought to his work for television. "There is a positive, consistent, and coherent way, one that respects the intelligence, good taste, and capacity of an audience."[65]

Bass's spot for Mennen Baby Magic lotion is a minute-long exercise in cinematic restraint and artistry. Accompanied by a succinct voiceover about the merits of the product and the responsibilities of motherhood, the commercial opens with an overhead shot of a naked baby seen through the haze of a diaphanous scrim. The fabric pulls away to expose the child surrounded by a stark, almost blinding whiteness, a kind of visual metaphor of birth. A series of rapid, tightly framed shots of body parts—the baby's hand, flexing feet, open mouth, and sleepy eyes, the mother's smiling face or her hands as she applies lotion to the child—conveys their intimate bond. The commercial's abrupt and disjointed editing, which increases the emotional intensity and visual impact, recalls the shower scene in Alfred Hitchcock's masterpiece *Psycho*, a segment that the director had asked Bass to storyboard.[66] This spot, like the best commercial work of the period, affirmed television's potential as an artistic medium.

Saul Bass (designer), opening credits for *Psycho*, 1960.

Saul Bass (director), stills from a television commercial for Mennen Baby Magic lotion, 1962.

Saul Bass (designer), opening credits for *Playhouse 90*, CBS, 1956.

Saul Bass (designer), opening credits for *Profiles in Courage*, ABC, 1964–65.

OPPOSITE
Saul Bass (designer), still from a promotional film for IBM, "History of Invention," 1962.

LEFT
Still from a television commercial for
Burlington Mills, 1970.

BELOW LEFT
Agnes Martin, *Tremolo*, 1962. Ink on
paper, 11 × 10 in. (28 × 25.5 cm). The Riklis
Collection of McCrory Corporation,
The Museum of Modern Art, New York.

OPPOSITE
Promotional photograph of Dorothy
Catherine Anstett, Miss USA, 1968.

For a brief period Op Art was a craze
in popular culture, inspired by its high
art sources.

ERNIE KOVACS'S "POST MODERN" PERFORM ANCES

Kovacs was more than
another wide-eyed,
self-ingratiating clown.
He was television's first
significant video artist.
He was its first great
surrealist. He was its
most daring and
imaginative writer. He
was . . . television's first
and perhaps only *auteur*.

William A. Henry III,
"Topsy-Turvy in the
Everyday World: The
Unsurpassed Career of
Ernie Kovacs"

Perhaps no performer in early television was more aware of the medium's material values and technological possibilities than the producer, writer, actor, and comedian Ernie Kovacs. His presence on television included *Pick Your Ideal* (WPTZ, c. 1950) and *Three to Get Ready* (WPTZ, 1951–52); *It's Time for Ernie* (NBC, 1951); *Ernie in Kovacsland* (NBC, 1951), a summer replacement for the revolutionary children's program *Kukla, Fran and Ollie* (NBC, ABC, 1947–57); various, and variously titled, versions of a nationally broadcast Ernie Kovacs show (CBS, NBC, DuMont, ABC, 1952–56, 1961–62); and guest appearances on numerous variety and comedy shows. While his own shows were praised by critics as innovative, they were largely ratings failures.

Concentrating on sketches and set pieces—featuring a panoply of zany characters impersonated by its host—*The Ernie Kovacs Show* was one of the first programs to understand and employ television as "a true 'medium,' capable of being conceived of and applied in a variety of ways."[67] Kovacs recognized the "potential of live electronic visual technology and manipulated its peculiar qualities to become a master of the sight gag."[68] He had grown up in Trenton, New Jersey, in a working-class Hungarian American immigrant family, and his madcap satire targeted elites as well as popular culture, through such figures as the fey poet Percy Dovetonsils and the perennially tipsy host of a cooking show, Miklös (Miklosh) Molnar.

Kovacs's performances, daft and emphatic in tone, implored viewers to "sit up and take notice [and] pay attention."[69] To make his material more visually compelling,

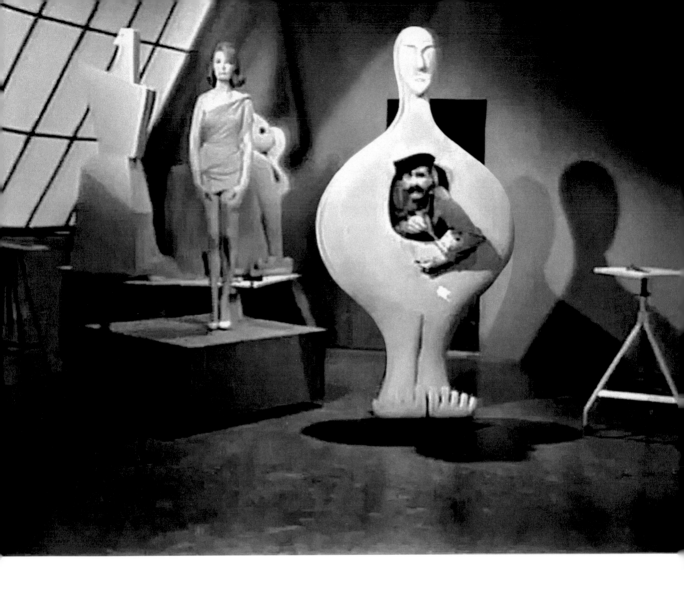

Stills from *The Ernie Kovacs Show*, ABC,
1961–62.

he appropriated special effects from Dada, Surrealist, and other genres of avant-garde film: dream sequences; kaleidoscopic imagery; autonomously moving inanimate objects; disorienting camera angles; extreme close-ups; long, overhead, and underfoot shots; and extensive fade-outs, dissolves, double exposures, superimpositions, and rear-screen projections. Kovacs's vivid sight gags also owed much to avant-garde art, as in the skit "School for Skin Divers," in which an underwater Kovacs, dressed in a suit and tie and typing at a desk, pays homage to the submerged juggling scene in Man Ray's 1929 film *Les Mystères du Château de Dé (The Mysteries of the Château of Dice)*.[70] Kovacs's use of aural effects was equally innovative. Borrowing from avant-garde music, he employed ordinary, repetitive sounds, or sharp, disruptive noises, or unmelodic phrases—the gurgling of a drainpipe, the clink of a glass, the explosion of a miniature cannon—as the sound track for many of his on-air performances.

"Kovacs's genius lay in the realm of art," wrote William A. Henry III. "There, a genius is someone who causes audiences to look at the world in a new way."[71] Kovacs continually violated television's conventions and predictability. He began with seemingly logical and benign situations—a guest being interviewed by a talk-show host, or a performance of the ballet *Swan Lake*—only to "repeatedly pull the rug out from under the viewer with bizarre and frequently macabre actions."[72] (*Swan Lake*, for example, was danced in gorilla costumes.) He mocked bourgeois culture and society, especially its pretensions, excesses, and blind spots. And he challenged authority and conformity, publicly excoriating corporate brass for trying to rein him in.[73]

As if to underscore this rebelliousness, an important part of his meticulously cultivated public image, Kovacs published a novel, *Zoomar* (1957), about a broadcast executive's descent into insanity. It was a brutal sendup of the wastefulness, shabby programming, and suspect business practices of network television. His frequent asides to the home audience—he acknowledged that "money is power in a capitalist society"—were meant to reveal not only the corporate interests that underwrote television and dictated its content, but also the bankruptcy of capitalism's investment in the idea of money as a signifier of quality.[74] On an ABC special, Kovacs made his feelings clear to viewers: "The money means nothing. The money *is* nothing. It is very, very little."[75]

Attempting to place Kovacs in an art historical context, arguing for his work as a form of avant-garde practice, J. Hoberman considers his formalist sensibilities, especially the "attention his work calls to its own materials, the condition of its making, and its place in the history of art."[76] Kovacs viewed television as an

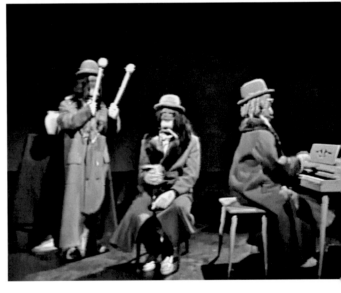

Stills from *The Ernie Kovacs Show*, NBC,
1955–56, and ABC, 1961–62.

"intimate vacuum," in which "two disengaged parties (the show and the viewer) [were] only connected in the performance by the TV broadcast transmission."[77] For Kovacs, television was a medium to be explored "for its own intrinsic value and approach," a neutral site "for experimenting with both visual and audio content.[78] This "vulgar modernism," as Hoberman calls it, pushed the aesthetic and conceptual boundaries of the medium within the context of popular culture.[79] In keeping with other manifestations of modernism for the masses—the work of the animators Tex Avery and Frank Tashlin, the musician Spike Jones, the editor and cartoonist Harvey Kurtzman and his followers at *Mad* magazine, for instance—Kovacs's contribution was both self-conscious and hypercritical of the cultural milieus in which it operated.

Kovacs's exploration of television's intrinsic material values went beyond mere formalism. As the philosopher Walter Benjamin commented about another time-based genre, film resists the focused and contemplative act of viewing that is central to the experience of painting. While the spectator can "abandon himself" to a canvas's material pleasures and allusions, he cannot do so before a motion picture. "No sooner has his eye grasped a scene than it has already changed," Benjamin pointed out. "It cannot be arrested."[80] It is this feature, among many others, that impels Kovacs's experimental and self-conscious work beyond the historical realm of modernism to the quintessentially postmodern sensibility of television. Hoberman comments:

> Certainly, television can be seen to embody what are generally held to be postmodernism's most obvious characteristics—appropriation, pastiche, recycling, a mixture of nostalgia and ahistoricism, the blurring of the distinction between art and entertainment, high modernism and mass culture, and the substitution of the media system for the natural world. Indeed, two postmodern traits cited by Fredric Jameson—"the transformation of reality into images" and "the fragmentation of time into a series of perpetual presents"—virtually define television.[81]

Kovacs's inventive approach to the medium prefigured video art and other high-culture applications of television technology that emerged in the 1960s. His aggressive use of camera manipulation and special effects, such as split screens, double exposures, and negative images, foreshadowed the work of the video art pioneer Nam June Paik by nearly a decade. Ultimately, Kovacs's work was comparable to the postmodernist aesthetics that appeared in the late 1960s and

the 1970s, which experimented with new technologies, involved viewers in direct and nonhierarchical ways, and employed the imagery, sensibility, and content of mass media in order to question its ideological imperatives.[82]

Kovacs emphasized "television's transformation of reality into images" by demystifying its illusions, a process typical of postmodernism. Neither magical nor seamless, the television picture was repeatedly revealed for what it was—an amalgam of electronic signals shaped by myriad procedures, conventions, and cues. Kovacs opened some of his programs not from the stage but from the control room, visibly giving instructions to compliant directors and cameramen. As if to underscore the demystification, he often ended his shows with an ironic sign-off, "It's been real." Riffing on the "existential quality" of live television, he welcomed on-air mistakes and flubs.[83] And he invited home viewers to participate in the communicative or creative process, addressing them pointedly and directly and encouraging them to take photographs of his shows as they were being televised and send them in.

"Ernie Kovacs was, first and foremost . . . television's great subversive," says the journalist Jeff Greenfield.[84] Kovacs's work, in its aesthetic and technological experimentation and content, challenged and disrupted the status quo. And while it may have been ahead of its time, it also demonstrated the extent to which television could rival the inventiveness and aesthetic complexity of high culture—a legacy evident in such later pioneering programs as *In Living Color* (FOX, 1990–94), *Rowan & Martin's Laugh-In*, and *Saturday Night Live* (NBC, 1975–present).

Ernie Kovacs, *Zoomar: A Sophisticated Novel about Love and TV*, Doubleday, 1957.

Ernie Kovacs Show studio prop, c. 1956.
Pigment on foam rubber. Private collection.

THE
MUSEUM OF
MODERN
ART
TELEVISION
PROJECT

I believe our greatest
opportunity lies in
that much abused
medium of television.
That vicious little box
sits in everybody's
living room and has
taken possession of
the minds of America.
But television can be
used for good as it
can bring aesthetic
experiences into every
classroom, art center
and home.

Victor D'Amico, director
of education, Museum
of Modern Art

The aesthetic ambitions and inventiveness of early television posed a question about its cultural status: Was it art? In the late 1940s and the 1950s, the art museum was a forum for this debate and an important cultural site for examining the possibilities and social and cultural implications of the medium. In 1950, the Museum of Modern Art in New York, which by then was participating in TV programs on average once a week, informally polled American art museums about their "use of and appearance on television."[85] While some institutions had ignored the medium, many had embraced it, including the Art Institute of Chicago, the Institute of Contemporary Art in Boston, the Metropolitan Museum of Art in New York, the Yale University Art Gallery in New Haven, and the Seattle Art Museum.

As early as 1941, the Metropolitan Museum of Art had partnered with the local CBS affiliate to produce experimental programs that introduced its collection to a general television audience. "We are living in a visual age where the complexities of modern civilization demand a minimum of words and a maximum of images," wrote Francis Henry Taylor, then president of the museum. "Television will be the instrument which will create . . . a revolution in education of the future."[86] In 1954, NBC aired a nationwide public affairs program, *A Visit to the Metropolitan Museum of Art*, broadcast in color and devoted to the institution's extensive collections.

One of the most significant manifestations of the interface between television and the avant-garde was the Museum of Modern Art Television Project, established in 1952 through a grant from the Rockefeller Brothers Fund and directed by the

avant-garde filmmaker Sidney Peterson with Douglas MacAgy, special consultant to the director of the museum.[87] A major goal of the project was to produce lucid and dynamic programs about modern art, pitched to a broad television audience.[88] The Television Project took advantage of the creative potential of the young medium, working with the commercial networks on experimental programming, educational series, and other content designed to inform viewers about avant-garde art and to influence the look and sensibility of television through modernist ideals and principles. The relationship between the museum and television was symbiotic: local broadcasters and national networks "were hungry for anything that could catch the visual attention of the viewers."[89] In this regard, the museum sought out the heads of the three major networks, Leonard Goldenson (ABC), William Paley (CBS), and David Sarnoff (NBC), to encourage their participation in the Television Project.[90]

The project focused on female viewers, following Peterson's notion that men were "not a significant audience for arts programming" and that women were more open to being educated about art and more tolerant of novel aesthetics, despite the museum's concentration on male artists.[91] As Lynn Spigel observes, this viewpoint accorded with the museum's broader democratizing goal: to reconcile "the work of art, everyday life, and consumerism" and to endorse "modern art within a vernacular mode that spoke the language of 'ordinary' people—particularly the housewife."[92]

OPPOSITE
Marketing a portable television, late 1950s.

RIGHT
Still from *Through the Enchanted Gate*, The Museum of Modern Art and WNBC, 1952.

Installation view, *8 Automobiles*,
The Museum of Modern Art,
New York, 1951.

OPPOSITE
Installation view, *Textiles and Ornamental
Arts of India*, The Museum of Modern Art,
New York, 1955.

The Museum of Modern Art remained ambivalent about the Television Project throughout its three-year existence.[93] In 1952, *Through the Enchanted Gate*, a short-lived series that encouraged children to make art, was created by the museum's director of education, Victor D'Amico, and produced by MoMA in collaboration with WNBC-NBT. Three years later, Sidney Peterson conceived a film for children—*The Invisible Moustache of Raoul Dufy*—and negotiated a production deal among MoMA, NBC, and United Productions of America (UPA), a major Hollywood animation studio. The museum found that the completed film did not "further the cause of modern art," and demanded that its name be removed from the project.[94] In the same year, MacAgy completed a study, *The Museum Looks In on TV*, that concluded that traditional aesthetics were ill suited to television and that the fast-paced and distracting medium compromised meditative high art.[95]

Despite the museum's ambivalence, the Television Project challenged an abiding cultural myth: that television was the opposite of art in terms of quality and content. The project was not inconsistent with the mission of a museum that was, in the 1950s and 1960s, actively expanding the definition of modernist culture. In a series of inventive exhibitions, MoMA promoted an array of material culture outside "traditional" painting, photography, and sculpture, including children's art (exhibited annually from the late 1940s through the 1950s), *New York Times* posters (1952),

automobile design (1951, 1953), Indian textiles and ornamental art (1955), animated cartoons (1955), photographs of graffiti (1956), travel posters (1957), Japanese vernacular graphics (1961), design for sport (1962), and horror film stills (1965).

While museum exhibitions and programs involving mass culture were popular with the public, they were sometimes dismissed by art world insiders as inauthentic, overly concerned with vernacular culture, or vulgarizing the museum's high-modernist mandate. This was especially a problem with MoMA's Television Project. In 1952, as part of the initiative, the museum considered building a television archive comparable to its renowned film library. But the idea of collecting television memorabilia was met with skepticism, both inside and outside the institution. The film library director, Richard Griffith, demurred; film people, he felt, "hate TV" and would accept its inclusion in the collection only "as long as it is not [in] the same department as the film library."[96]

OPPOSITE
Installation view, *Animated Cartoons*,
The Museum of Modern Art,
New York, 1955.

Installation view, *Design for Sport*,
The Museum of Modern Art,
New York, 1962.

Installation view, *Photographs of
Graffiti*, The Museum of Modern Art,
New York, 1956.

Its misgivings about mass culture notwithstanding, MoMA supported the medium well after the Television Project disbanded in 1955—the same year the museum's director, Alfred H. Barr Jr., appeared on the NBC morning program *Home* to publicize the museum. In 1962, the museum organized *Television U.S.A.: 13 Seasons*, a retrospective of golden age programs as well as television commercials. The catalogue—with cover art by Ben Shahn—argued that television was divided into two camps: one driven by profits, the other by artistic excellence; the latter was the subject of the exhibition. Five years later, the museum established a Television Archive of the Arts under the auspices of its Junior Council, devoted to network programming about modern art and ideas.[97]

TELEVISION U.S.A.: 13 SEASONS

THE MUSEUM OF MODERN ART FILM LIBRARY

OPPOSITE
Installation view, *Japanese Vernacular
Graphics*, The Museum of Modern
Art, New York, 1961.

Ben Shahn (cover artist), *Television U.S.A.:
13 Seasons*, The Museum of Modern
Art, New York (producer), 1962. Private
collection.

EPILOGUE: TELEVISION AND MODERNITY

In pre-modern societies, space and place largely coincide, since the spatial dimensions of social life are, for most of the population, and in most respects, dominated by "presence"—by localized activities. The advent of modernity increasingly tears space away from place by fostering relations between "absent" others . . . distant from any given situation of face-to-face interaction.

Anthony Giddens,
The Consequences of Modernity

Television was an apt subject for a museum devoted to the study and exhibition of modernism. If avant-garde art represented the high-end manifestation of the "modernist visual revolution," as the art historian Jonathan Crary has called it, television proffered its mass cultural potential.[98] To one extent or another, both capitalized on this transformation in the nature of seeing and recording reality, which had begun in the nineteenth century and which had come to define contemporary life by the middle of the twentieth. And both were driven, provoked, or influenced by the evolving technologies and inventions of visual media.

Modernism was not monolithic. It took many forms and flourished in many nations and circumstances. As such, its influence on American television was multivalent and complex. But it was modern art's revolutionizing of the act of seeing and its subversion of the "possibility of a contemplative beholder" in the traditional art historical sense that represent its most important convergence with television.[99] The industrial world as it arose in the nineteenth century, epitomized by Paris, New York, London, and other burgeoning urban centers, provided layered and ever-shifting optical experiences, where the process of observing, to quote Crary, was "always multiple, adjacent to and overlapping with other objects, desires, and vectors."[100] For the painter Marc Chagall, these overlapping vectors were embodied in the light and visual dynamism of his adopted city of Paris: "I aspired to see with my own eyes what I had heard of from so far away: this revolution of the eye, this rotation of colors, which spontaneously and astutely merge with one another in a flow of

conceived lines . . . [and which] could not be seen in my town. The sun of Art then shone only on Paris."[101]

This "revolution of the eye"—as CBS News and the Museum of Modern Art described it, echoing Chagall, in the title of a 1957 documentary on avant-garde painting they co-produced—extended not only to everyday urban life, but also to modern art. As Crary writes:

> The observer of paintings in the nineteenth century . . . simultaneously consumed a proliferating range of optical and sensory experiences. In other words, paintings were produced and assumed meaning not in . . . aesthetic isolation, or in a continuous tradition of painterly codes, but as one of many consumable and fleeting elements within an expanding chaos of images, commodities, and stimulation.[102]

A century apart, early avant-garde painting, at the birth of modernism, and television, on the cusp of postmodernity, captured the radical realignment of culture and technology. If modern painting represented a dramatic break with traditional realist art, it eventually proved too esoteric to transform society as a whole. Television, however, was a socially transformative medium, infiltrating everyday life with an expanding chaos of images that has forever altered our perception and understanding of the world.

The relationship between modern art and early television went far beyond the influence of the former on the latter. The connection between art and television—within the context of their shared modernist ambitions—cut both ways: avant-garde artists were also responding directly, and largely negatively, to a commercial medium that alternately inspired, fascinated, and influenced them and was influenced by them. In an epochal series from the early 1960s, the photographer Lee Friedlander "captured the comforts, intrusions, and aggravations of a world where the television always glows."[103] The art historian John Alan Farmer observes that these photographs, which were first published in *Harper's Bazaar* in 1963, depict the ubiquitous monitor not as a benign presence, but as an "ominous intruder," with "perhaps most frightening . . . the sets that feature close-ups of eyes." In these photographs, which, Farmer continues, "evoke scenes from 1950s science-fiction films and foreshadow the 1980s classic *Videodrome*, it is almost as if the sets represent a new type of human being, whose physical body has been dematerialized into the flux of electromagnetic transmission and is contained in a chassis, from

Lee Friedlander, *Florida*, 1963. Gelatin
silver print. Collection of the artist.

Dennis Hopper, *Kennedy Funeral*,
1963. Gelatin silver print, 16 × 24 in.
(40.6 × 61 cm).

Charles Addams, cover of *Show*, April 1962.

Peter Arno, cover of *The New Yorker*,
September 30, 1950.

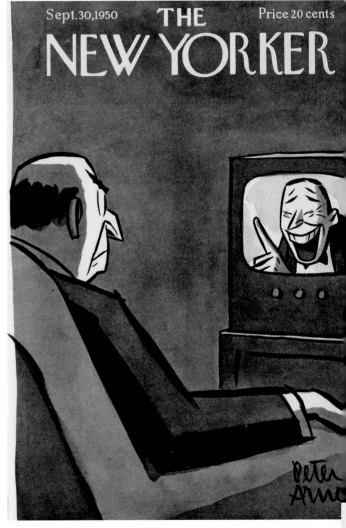

which it monitors those still yoked by the burden of physical bodies."[104]

This startling view of the medium was, by the mid-1960s, pervasive in artistic and academic circles. It was also gaining traction in the culture at large. As early as 1950, a magazine cover by Peter Arno for *The New Yorker* depicted a grumpy man watching television while an on-air personality tries to hypnotize him into a stupor. A decade later, Charles Addams's cover for *Show* magazine went further in its allusion to manipulation and mind control: a focus group of prisoners in a dungeon, positioned in front of a television screen, is wired to detectors that measure their every response as a form of torture. Arno's apprehensions were echoed by cultural critics and social scientists of the day, who ascribed to the medium various negative and even dangerous traits—from inherently addictive qualities to the potential to "ruin eyesight and corrupt youth."[105]

Much of this criticism centered on the corporate ambitions for television as a form of entertainment designed, above all, to sell products. For the philosopher Günther Anders, television sold products most effectively by pacifying viewers into emotional and intellectual inactivity: "Because the receiving sets speak in our place, they gradually deprive us of the power of speech, thus transforming us into passive dependents."[106] The social critic Dwight Macdonald—extrapolating from an essay by the art critic Clement Greenberg on mass media's debasement of high culture—concluded: "The Lords of *kitsch*, in short, exploit the cultural needs of the masses in order to make a profit and/or to maintain their class rule."[107]

This criticism, in part, contributed to a waning artistic interest in broadcast media, and impelled a new generation of artists to question the very medium that had inspired them. Examining the relationship of these artists to early television, the art historian David Joselit defines their target: a manipulative TV industry, doggedly promoting a "lifestyle appropriate to consumer life" in which the networks sell products, financially enriching themselves and their sponsors.[108] In this highly commercial realm, viewers were transformed into commodities as well, vied for by the networks, scrutinized and quantified by Nielsen Media Research (which managed the ratings system), and lulled into believing that they were participating in a democratic process driven by their tastes and choices.[109]

This view was echoed in a number of works by avant-garde artists of the period. In Bruce Conner's *Report* (1963–67), the artist, disturbed by television coverage of the Kennedy assassination, employed news footage to consider how the medium turned the death of a president into a national spectacle. Dennis Hopper's series of photographs of television screens, *Kennedy Funeral* (1963, page 101), similarly

questioned the medium's unrelenting and ubiquitous coverage of consequential news events, with a deadpan blandness that both reinforced the dimension of the tragedies it sometimes represented and dulled their emotional edge through repetition. A little later, Edward Kienholz incorporated a tombstone-shape console television into *The Eleventh Hour Final* (1968, page 107), an installation work protesting the Vietnam War, set in a bland family room. Nam June Paik and Otto Piene's *Untitled* (1968, page 106) consists of a television covered in faux pearls, except for its screen, a Conceptual sculpture that alludes to the medium's low-culture ambitions, its co-option by sponsors and money, and the powerful role it plays in culture and society. Yoko Ono's *Sky TV* (1966, page 107), a monitor showing the 24/7 input of a video camera mounted on a roof, facing up to the sky, suggests a seemingly optimistic view of the medium, hinting at its aesthetic potential and its infinite cultural possibilities. But if *Sky TV* celebrates television technology, its closed-circuit structure—in which the artist establishes the rules for transmission, institutions select the style and location of its reception, and nature provides the content—offers an aesthetic alternative to the profit-driven content of broadcast television.

The availability of TV technology outside a corporate environment, especially Sony's marketing of the first portable videotape recorder in 1967, gave rise to a video art movement that, in turn, hastened the demise of the symbiotic and mutually generative relationship between modern art and broadcast television. In some instances—the video work of Ilene Segalove; the Pop paintings of Idelle Weber, inspired by the modern look and sensibility of television—artists took a more positive view of the commercial medium and its creative and social promise. Others took aim at it, while many used television technology in the service of abstraction or to pursue personal, psychological, or political themes. An important precursor of video art was *Television Décollage* (1958), by the German artist Wolf Vostell. The installation incorporated a series of TV sets, some mistuned or with misaligned images, others splattered with paint, covered with canvas, or shot with bullets, announcing the artist's desire to flout the aesthetic limitations of commercial television. Out of such experimentation emerged a video art movement that employed video data (as opposed to analogue motion picture film) to make complex aesthetic and social statements. From the late 1960s through the 1970s, a range of visual artists adopted the new discipline, among them Vito Acconci, John Baldessari, Lynda Benglis, Peter Campus, Terry Fox, Dan Graham, Gary Hill, Joan Jonas, Bruce Nauman, Nam June Paik, Martha Rosler, Ilene Segalove, Richard Serra, Willoughby Sharp, and Keith Sonnier.

As the movement grew, groups and collectives devoted to video art and alternative uses of television technology were founded—Ant Farm (1968), Raindance Foundation (1969), Videofreex (1969), and People's Video Theater (1970) among them. The National Endowment for the Arts and the New York State Council on the Arts began supporting artists' video productions. Major exhibitions validated and helped define the new movement, including the first devoted exclusively to video art—*Television as a Creative Medium*, at the Howard Wise Gallery in New York in 1969. Other shows and programs followed, at the Whitney Museum of American Art and the Solomon R. Guggenheim Museum in New York, the Everson Museum of Art in Syracuse, the Walker Art Center in Minneapolis, the Berkeley Art Museum, the Institute of Contemporary Art in Boston, and the Rose Art Museum at Brandeis University. By the mid-1970s, the Museum of Modern Art, having turned its attention away from commercial television, began collecting video art, further legitimizing its high-art status.

While avant-garde artists were abandoning commercial television, one visual artist continued to employ it directly—Andy Warhol. He considered television an extension of his creative and political practice: as an award-winning designer for CBS and NBC in the early 1950s; as a "performer" on network television programs, such as *The Love Boat* (ABC, 1977–86) and *Saturday Night Live* (page 108); as a cable television producer; as a celebrity who posed for Sony videotape advertisements; and as a commentator on the medium through works such as *$199 Television* (1961, page 111) and *Outer and Inner Space* (1965, page 112).[110] On one occasion in 1968, he directed and shot a television commercial for the Schrafft's chain of restaurants, producing a psychedelic ad for an ice-cream sundae (page 109). He even conceived of his day-to-day life as an ongoing television show, "a movie made for TV," as he described it.[111]

Appropriating broadcast formats and sensibilities, Warhol rejected the solipsism and abstruseness of much video art—what the art historian Rosalind Krauss has called the "aesthetics of narcissism."[112] The curator and critic Judith Benhamou-Huet notes that if video artists attempted to disrupt the normal flow and style of broadcast TV, Warhol, on the contrary, "played the media game."[113] He used the medium practically, adapting traditional techniques and standards—from makeup and lighting to the swift pacing of scriptwriting and film editing. To traditional television, he introduced "new faces, new sounds, a seductiveness, celebrity. If we keep in mind who Warhol was, it was . . . his way of doing 'ready-made' television programs."[114]

Nam June Paik and Otto Piene, *Untitled*,
1968. Manipulated television set and plastic
pearls, 9 × 13 × 10 in. (22.9 × 33 × 24.4 cm).
The Museum of Modern Art, New York.

Yoko Ono, *Sky TV*, 1966. TV monitor, closed circuit video camera, dimensions variable. Collection of the artist.

Edward Kienholz, *The Eleventh Hour Final*, 1968. Room installation, mixed media. Kunsthalle Hamburg, Germany.

The lit television screen displays a weekly "kill ratio" (American dead and enemy dead) of the kind that was routinely broadcast during the Vietnam War by network news programs in the United States.

This is not to say that Warhol's media game was not transgressive. His approach to popular culture was motivated not just by fascination and grudging respect, but by a need to critique its faults and push it as far as he could. If his response to television also violated some of its conventions and taboos—introducing overt and confident gay sexuality into a commercial sphere virtually devoid of it, for example—it was also enacted in a decidedly public context.

Warhol's interventions, of course, did not always come naturally to television. In the 1960s and 1970s, gay sexuality was a difficult and fraught subject for mainstream media. Broadcast television was rife with homophobia, exemplified by the scornful and sensationalistic depiction of gay men on the 1967 CBS News documentary *The Homosexuals*. But television's enormous cultural reach provided Warhol with the clearest path to influence and fame, his own "fifteen minutes," the period in the spotlight to which each person, he believed, was entitled. Television also provided a lively cultural space that, despite its shortcomings and prejudices, was attractive to an openly gay artist working in an art world seething with homophobia and machismo. Ultimately, Warhol viewed television much as Barbra Streisand viewed modernism (and, by extension, television): as a milieu rife with creative possibilities, a place where he was freer to be himself.[115]

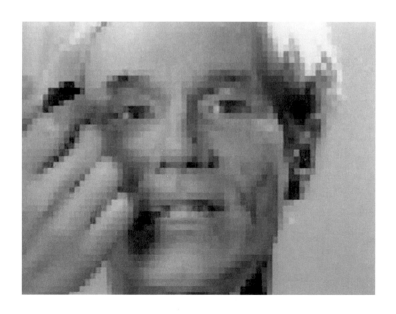

Andy Warhol's face dissolving, still from a film for *Saturday Night Live*, NBC, 1981. The Andy Warhol Museum, Pittsburgh.

Andy Warhol (director), stills from a
television commercial for Schrafft's ice
cream, "The Underground Sundae"
(unofficial title given by the artist), 1968.
Kramlich Collection.

Still, by the early 1970s, network television had effectively lost interest in avant-garde art, just as visual artists were producing abstruse videos free of the commercial pressures of network television.[116] The epoch when television and the avant-garde saw in each other the possibility of mutual promotion and advancement had drawn to a close. But this relationship went beyond cynicism. If the networks appropriated the forms and sensibilities of vanguard art in order to improve their image, they also supported producers, writers, directors, and on-air talent who saw themselves as artists. There is no doubt that the Academy Award–winning writer Paddy Chayefsky, penning scripts for the dramatic anthology series *The Philco Television Playhouse* (NBC, 1948–55) and *20th Century–Fox Hour* (CBS, 1955–57), and Rod Serling, tweaking Surrealist forms and ideas for *The Twilight Zone*, and Ernie Kovacs, summoning a Dadaist universe week after week, were intent on making quality television. And they were not alone. Each season, scores of national and local programs elevated the medium to a "popular art," as the pioneering television historian Horace Newcomb has called it.

Despite commercial television's sometimes negative profile in academia and high culture, it was far from an aesthetic and social wilderness. If critics point to its rapaciousness, structural limitations, or adverse effects on society, they usually base their conclusions on a reductive or stereotypical view of its programming.[117] As the subversive content of more academically validated disciplines, such as literature, film, and visual art, affirms—work that is also sold and distributed for profit—insurrection, creativity, and aesthetic excellence were possible within, or in spite of, a corporate framework. Network appearances by artists were no less important because of their institutional context, even if much of their audience was uninterested in or bewildered by their work. If Marcel Duchamp, Georgia O'Keeffe, and Ben Shahn, like thousands of other famous people, were making "commercials for themselves," they were also exposing millions of viewers to challenging and progressive ideas and images.[118]

While the vast majority of programs in the 1950s and 1960s espoused safe, middle-class values, they were not always as bland as their critics maintain. In television's formative years, innovative dramas, situation comedies, and interview and news programs tackled such controversies as racism, anti-Semitism, abortion, gay and lesbian sexuality, feminism, war, poverty, the criminal justice system, and political corruption and zealotry.[119] And producers, directors, writers, and performers sometimes openly defied the medium's corporate mind-set, most famously Kovacs and Serling.[120] The latter's critically acclaimed teleplay *Patterns*, produced for the

Andy Warhol, *$199 Television*, 1961. Oil
on canvas, 68 ⅛ × 52 ⅜ in. (173 × 133 cm).
Whitney Museum of American Art,
New York.

anthology series *Kraft Television Theatre* in 1955, was a scathing "tale of corporate morality—or the lack of it—and such everyday battles as the ones waged between conscience and ambition."[121]

In the end, the freshness and novelty of the medium contributed to its penchant for aesthetic and conceptual invention: television's first three decades were coextensive with its most aggressive exploration of avant-garde forms and sensibilities. This period of inventiveness, purposely or incidentally, also created a cultural space that was itself somewhat more open to diverse aesthetic, conceptual, and social points of view. Together, the unique attributes of the new medium, unfolding at a pivotal time in American history, offered a cutting-edge form of visual communication, one that forever altered American society and culture.

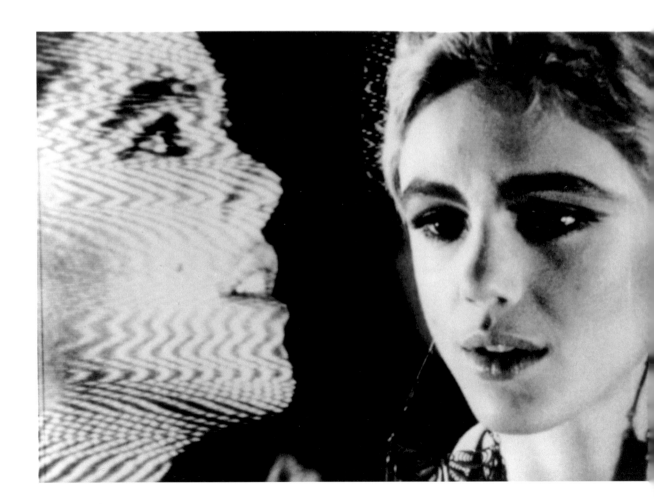

Andy Warhol, still from *Outer and Inner Space*, 1965. The Andy Warhol Museum, Pittsburgh.

Outer and Inner Space, Warhol's first double-screen film, features Edie Sedgwick sitting in front of a television monitor on which is playing a prerecorded videotape of herself. The two segments are spliced together on two separate reels of film, creating a split screen with four close-ups of the actress. Two of the images show Sedgwick speaking spontaneously to the camera, while in the other two she is speaking to someone off-screen, commenting on watching herself on television.

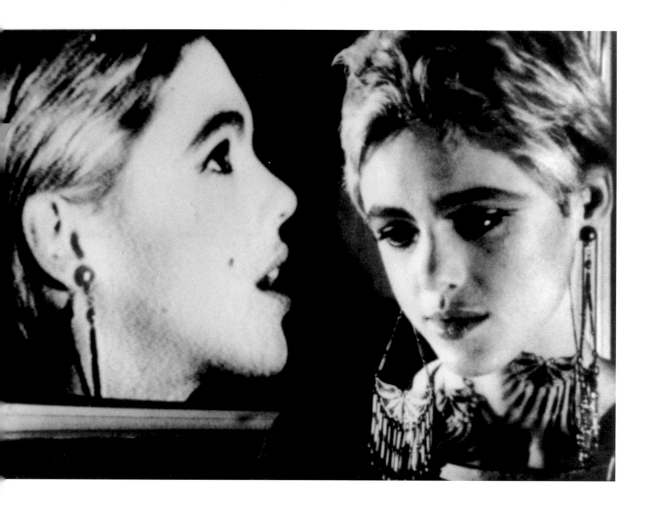

NOTES

Horace Newcomb, *TV: The Most Popular Art* (New York: Anchor, 1974), 15; William Golden, "Type Is to Read," *Typography—U.S.A.* (New York: Type Directors Club of New York, 1959), reprinted in *The Visual Craft of William Golden*, Cipe Pineles Golden, Kurt Weihs, and Robert Strunsky, eds. (New York: George Braziller, 1962), 21–25; Aline Saarinen, "What about the Cultural Explosion?" unpublished essay, n.d., Archives of American Art, box 5, folder 6, 2; William A. Henry III, "Topsy-Turvy in the Everyday World: The Unsurpassed Career of Ernie Kovacs," in *The Vision of Ernie Kovacs* (New York: Museum of Broadcasting, 1986), 10; Victor D'Amico, as quoted in Nancy Shaw, "Modern Art, Media Pedagogy, and Cultural Citizenship: The Museum of Modern Art's Television Project, 1952–1955," PhD diss., McGill University, 2000, 84; Anthony Giddens, *The Consequences of Modernity* (Stanford, CA: Stanford University Press, 1990), 18.

1. "Gotta Move" was written especially for the program by Peter Matz, Streisand's arranger and composer.

2. The song was cowritten by Armand Canfora and Joss (Joseph) Baselli. According to Lynn Spigel, the scene recalls the "painting comes to life" sequence in the director Vincente Minnelli's film *An American in Paris* (1951). See Spigel, *TV by Design: Modern Art and the Rise of Network Television* (Chicago: University of Chicago Press, 2009), 167.

3. Spigel, *TV by Design*. While the exhibition *The New Frontier: Art and Television 1960–65*, organized by John Alan Farmer for the Austin Museum of Art in 2000, touched on the subject, it concentrated on avant-garde art and the ways artists have interpreted, appropriated,

and commented on television. The seminal work of the television historian Horace Newcomb, who has argued for the consideration of the medium as an American popular art form, is an important precursor to the present project. See, for example, Newcomb, *TV: The Most Popular Art*; Horace Newcomb, ed., *Television: The Critical View* (London: Oxford University Press, 1976); and Horace Newcomb and Robert S. Alley, *The Producer's Medium: Conversations with Creators of American TV* (London: Oxford University Press, 1983).

4. Spigel, *TV by Design*, 69.

5. Marshall McLuhan, *Understanding Media: The Extensions of Man* (New York: Routledge, 2001), 276. For an important early text on the influence of television, see Leo Bogart, *The Age of Television: A Study of Viewing Habits and the Impact of Television on American Life*, 2nd ed. (New York: Frederick Ungar, 1958).

6. For more on this subject, see Maurice Berger, *For All the World to See: Visual Culture and the Struggle for Civil Rights* (New Haven: Yale University Press, 2010), 98–137.

7. Horace Newcomb, correspondence with the author, September 23, 2013.

8. Eugene Burdick et al., *The Eighth Art: Twenty-Three Views of Television Today* (New York: Holt, Rinehart and Winston, 1962).

9. Ashley Montagu, "Television and the New Image of Man," in Burdick et al., *Eighth Art*, 126.

10. See Igor Stravinsky, George Balanchine, and Robert Craft, "Notes for *The Flood*," in Burdick et al., *Eighth Art*, 269.

11. Spigel, *TV by Design*, 27.

12. Minow was not dismissing network television entirely; he acknowledged that some of its programs were of quality.

13. Thomas Crow, *Modern Art in the Common Culture* (New Haven: Yale University Press, 1998), 35.

14. See Spigel, *TV by Design*, 12.

15. Serling's daughter Anne discusses his reputation as an "angry young man" in *As I Knew Him: My Dad, Rod Serling* (New York: Citadel, 2013), 95–97.

16. Dan Duryea, as quoted in Arlen Schumer, *Visions from The Twilight Zone* (San Francisco: Chronicle, 1990), 21.

17. Ayn Rand, as quoted in Schumer, *Visions from The Twilight Zone*, 22.

18. For more on the show's melding of genres, see Peter Wolfe, *In the Zone: The Twilight World of Rod Serling* (Bowling Green, OH: Bowling Green State University Popular Press, 1997), 23–24.

19. Arlen Schumer, "The Twilight Zone Forever," The Paley Center for Media, www.paleycenter.org/the-twilight-zone-forever.

20. Arlen Schumer, as quoted in Randall Rothenberg, "The Synergy of Art and 'The Twilight Zone,'" *New York Times*, April 2, 1991, C16.

21. André Breton, "Second Manifesto of Surrealism" (1930), as quoted in James Williamson, "Acropolis, Now!" in *Surrealism and Architecture*, ed. Thomas Mical (New York: Routledge, 2005), 320. For more on the connection between the two texts, see Schumer, "Twilight Zone Forever."

22. Schumer, "Twilight Zone Forever."

23. George Clayton Johnson, as quoted in ibid.

24. Pierre Reverdy, as quoted in Louise Tythacott, *Surrealism and the Exotic* (New York: Routledge, 2004), 67.

25. For Serling's Surrealist sources, see Schumer, "Twilight Zone Forever." The credit sequence was designed by Pacific Title & Art Studio; a score by Bernard Herrmann was used in the first season.

26. Therese Lichtenstein, "The City in Twilight," in *Twilight Visions: Surrealism and Paris* (Berkeley: University of California Press, 2009), 11.

27. Lichtenstein, "City in Twilight," 1.

28. J. Hoberman, "Epilogue," in Schumer, *Visions from* The Twilight Zone, 151.

29. Ibid., 154.

30. Ibid. Such characters also connect *The Twilight Zone* to film noir, another genre that was partly a reaction against capitalist conformity. For more on this, see M. Keith Booker, *Strange TV: Innovative Television from* The Twilight Zone *to* The X-Files (Westport, CT: Praeger, 2002), 55.

31. Lichtenstein, "City in Twilight," 47–48.

32. Hoberman, "Epilogue," 156.

33. For more on the social, psychological, and existential imperatives of the New York School, see Norman L. Kleeblatt, ed., *Action/Abstraction: Pollock, de Kooning, and American Art, 1940–1976* (New York: The Jewish Museum, and New Haven: Yale University Press, 2008).

34. Hoberman, "Epilogue," 160.

35. Ibid.

36. R. Roger Remington and Barbara J. Hodik, *Nine Pioneers in American Graphic Design* (Cambridge, MA: MIT Press, 1989), 72.

37. For important analyses of aspects of the CBS design campaign, see Spigel, *TV by Design*, 68–109.

38. While no definitive connection has been made between the CBS eye symbol and Magritte, a number of versions of the logo, in advertisements and promotional materials, appear with clouds—a seemingly direct reference to the Magritte painting. For a critical assessment of the campaign, see Dennis P. Doordan, "Design at CBS," *Design Issues* 6, no. 2 (Spring 1990): 4–17. The CBS eye trademark had its origins in "The Gift to Be Simple," an article about Shaker design in the first issue (Winter 1950) of Alexey Brodovitch's short-lived journal *Portfolio*. Among the illustrations in the article was a Shaker "eye," an image strikingly similar to the CBS logo. Precise authorship of the CBS trademark is unclear. While most attribute the design to Kurt Weihs, under Golden's direction, other sources claim that Georg Olden was its uncredited designer. For more on the trademark, see William Golden, "My Eye," *Print* 13, no. 3 (May–June 1959): 32–35, reprinted in Golden, Weihs, and Strunsky, *Visual Craft of William Golden*, 151–55; and Julie Lasky, "The Search for Georg Olden," in *Graphic Design History*, ed. Steven Heller and Georgette Balance (New York: Allworth, 2001), 115–28.

39. Sagi Haviv, "The CBS Eye Logo," in Steven Heller, *Heart Design: Remarkable Graphic Design Selected by Designers, Illustrators, and Critics* (Beverly, MA: Rockport, 2011), 108.

40. For more on these commissions, see Spigel, *TV by Design*, 119–22, 140–50; and Vincent Scully,

"Rethinking Saarinen," Donald Albrecht, "The Clients and Their Architect," and Alexandra Lange, "Corporate Headquarters," in *Eero Saarinen: Shaping the Future*, ed. Eeeva-Liisa Pelkonen and Donald Albrecht (New Haven: Yale University Press, 2006), 13–29, 45–56, 276–87, respectively.

41. For an assessment of Golden's work, see Golden, Weihs, and Strunsky, *Visual Craft of William Golden*.

42. Golden, "Type Is to Read," 27.

43. Ibid., 27–29.

44. Spigel, *TV by Design*, 85. Also see Maud Lavin, *Clean New World: Culture, Politics, and Graphic Design* (Cambridge, MA: MIT Press, 2002).

45. William Golden, "The Background of Consumer Advertising," unpublished report, as quoted in Spigel, *TV by Design*, 107. For an assessment of Golden's work for CBS, see Remington and Hodik, *Nine Pioneers in American Graphic Design*, 72–85.

46. Georg Olden, as quoted in "Illustrating for Television," *American Artist* 18, no. 7 (September 1954): 42. Later in his career, Olden turned his attention to television programming, directing one episode of the ABC action series *The Mod Squad*. For more on his life and work, see "Georg Olden: Successful Art Director, Successful Host," *Ebony*, October 1951, 45–46; "The Man at the Window," *Ebony*, November 1960, 80–85; and Lasky, "Search for Georg Olden," 115–28.

47. Doordan, "Design at CBS," 13.

48. One of the "exhibitions," which included sound, photographic, and video elements, focused on major news stories during the history of CBS; another examined presidential

nominating conventions, a prelude to the network's 1964 summer coverage.

49. For more on the social and conceptual implications of Dorfsman's design program for CBS, see Ellen Lupton and J. Abbott Miller, "White on Black on Gray," *Design Writing Research: Writing on Graphic Design* (New York: Kiosk, 1996), 102–19. For a survey of Dorfsman's work for CBS, see Dick Hess and Marion Muller, *Dorfsman & CBS* (New York: American Showcase, 1987).

50. Doordan, "Design at CBS," 13.

51. For more on Graham, see Jennifer Jue-Steuck, "John J. Graham: Behind the Peacock's Plumage," *Design Issues* 19, no. 4 (Autumn 2003): 91–96.

52. Paul Rand, *Thoughts on Design* (New York: Wittenborn, 1947).

53. For a brief biography of Saarinen, see Donald Albrecht, "Clients and Their Architect," 54.

54. In addition to her regular appearances on *Today* and *Sunday*, Saarinen worked on two NBC News documentaries on American art institutions, featuring the Whitney Museum of American Art in 1967 and the Metropolitan Museum of Art in 1970. She was also host of the public affairs program *For Women Only* (NBC), which she left in 1971 to become the first female Paris bureau chief for NBC News.

55. Alden Whitman, "Aline Saarinen, Art Critic, Dies at 58," *New York Times*, July 15, 1972, A26.

56. Aline Saarinen, "Levels of Looking," unpublished essay, n.d., Archives of American Art, box 5, folder 6, 7.

57. Ibid.

58. Albrecht, "The Clients and Their Architect," 54.

59. For more on the "Warhol" episode, see Kyle Petreycik, "When the Joker Was a Contemporary Artist," *Hyperallergic*, March 22, 2013, http://hyperallergic.com/67524/.

60. For more on this, see Spigel, *TV by Design*, 259–62.

61. "Dinah Shore's TV Art," *Look*, December 15, 1953, 44–46; see also Spigel, *TV by Design*, 45.

62. Robert J. Wade, *Designing for TV: The Arts and Crafts in Television Production* (New York: Pellegrini and Cudahy, 1952), 112–13.

63. Ibid.

64. This realignment of the relationship between viewer and art object was the goal of many Minimalist sculptors of the mid-1960s, including Carl Andre, Donald Judd, Robert Morris, and Richard Serra. Their work was influenced by such philosophers as Maurice Merleau-Ponty and Charles Sanders Peirce, whose theories on "phenomenology" rejected an a priori and preordained understanding of things in the world. Rather than rely on logic and intellect for understanding what we see and do, phenomenology called for a direct, experiential interaction with the world. For more on the political and cultural motives for this shift, see Maurice Berger, *Labyrinths: Robert Morris, Minimalism, and the 1960s* (New York: Harper and Row, 1989).

65. Saul Bass, as quoted in Jennifer Bass and Pat Kirkham, *Saul Bass: A Life in Film & Design* (London: Laurence King, 2011), 96.

66. Bass designed *Psycho*'s title sequence and was asked by the director to prepare storyboards for the shower scene. After

Hitchcock's death, Bass claimed that he had actually directed the scene, an assertion denied by one star of the movie, Janet Leigh. For an illuminating frame-by-frame comparison of Bass's storyboards and actual stills from the film, see "Saul Bass's Storyboards for the *Psycho* Shower Scene," The Catholic University of America, http://faculty.cua.edu/johnsong/hitchcock/storyboards/psycho/sb-boards.html. For more on the shower scene, see Philip J. Skerry, *Psycho in the Shower: The History of Cinema's Most Famous Scene* (New York: Bloomsbury, 2009).

67. Lindsay E. Pack, "The Ernie Kovacs Show," *Encyclopedia of Television*, ed. Horace Newcomb, Museum of Broadcast Communications, www.museum.tv/archives/etv/E/htmlE/ErnieKovaksShow/erkovacshow.htm.

68. Ibid.

69. Jeff Greenfield, "Introduction," in *Vision of Ernie Kovacs*, 6.

70. Doyle Greene, *Politics and the American Television Comedy: A Critical Survey from* I Love Lucy *through* South Park (Jefferson, NC: McFarland, 2008), 53.

71. Henry, "Topsy-Turvy in the Everyday World," 10.

72. Greene, *Politics and the American Television Comedy*, 56.

73. Spigel, *TV by Design*, 198–200.

74. Henry, "Topsy-Turvy in the Everyday World," 13.

75. Kovacs, as quoted in ibid.

76. J. Hoberman, "It's Been Real: Ernie Kovacs Postmodernist," in *Vision of Ernie Kovacs*, 26.

77. Greene, *Politics and the American Television Comedy*, 60.

78. Ibid.

79. Hoberman, "It's Been Real," 26.

80. Walter Benjamin, "The Work of Art in the Age of Mechanical Reproduction," in *Illuminations: Essays and Reflections*, ed. Hannah Arendt, trans. Harry Zohn (New York: Harcourt, Brace and World, 1968), 238. For more on Benjamin and Kovacs, see Greene, *Politics and the American Television Comedy*, 54–71.

81. Hoberman, "It's Been Real," 31.

82. The concept of postmodernism gained currency and popularity in the mid-1980s, when Hoberman wrote his essay on Kovacs. For a critical appraisal of postmodernism in a historical context, see Maurice Berger, ed., *Postmodernism: A Virtual Discussion* (Baltimore: Center for Art, Design and Visual Culture, and Santa Fe: Georgia O'Keeffe Museum Research Center, 2003).

83. Hoberman, "It's Been Real," 26.

84. Greenfield, "Introduction," 6.

85. The poll was conducted by a letter sent to museums on June 22, 1950. For an accounting of MoMA's television appearances, see "Summary of the Report: The Museum and Television," The Museum of Modern Art, September 15, 1950, The Museum of Modern Art Archives, New York, EMH III.12d, 1. The museum's interest in television extended to its board of directors. In a 1948 memo to board president Nelson Rockefeller, a supporter of the new medium, museum staff proposed several initiatives with CBS to educate the public about modern art through lively television programming. Memo to Nelson Rockefeller, The Museum of Modern

Art, June 29, 1948, The Museum of Modern Art Archives, New York, EMH III.3, 1.

86. Francis Henry Taylor, as quoted in Spigel, *TV by Design*, 3.

87. For an illuminating study of the project, see Shaw, "Modern Art, Media Pedagogy and Cultural Citizenship." For more on Peterson's aesthetic philosophy, see Sidney Peterson, *The Dark of the Screen* (New York: Anthology Film Archives and New York University Press, 1980), and Stan Brakhage, *Film at Wit's End: Eight Avant-Garde Filmmakers* (New York: McPherson, 1989), 49–65.

88. Two years into the Television Project, the museum concluded that "with the exception of standard 'publicity' presentations, successful patterns for art programs addressed to the various types of television audience have yet to be found. In order to fulfill the purposes of the present study, it has therefore seemed necessary to take the initiative." "Progress Report: Television Project," The Museum of Modern Art, February 1954, The Museum of Modern Art Archives, New York, EMH III.17, 1.

89. Spigel, *TV by Design*, 148.

90. Sidney Peterson and Douglas MacAgy, n.d., The Museum of Modern Art Archives, New York, EMH III.15, 1.

91. Sidney Peterson, "The Medium," 1955, The Museum of Modern Art Archives, New York, R+P, 24.1, 5–6.

92. Spigel, *TV by Design*, 151.

93. As Lynn Spigel observes (ibid., 156), the museum remained caught between the need to appeal to a broad public and the goal to maintain the project's "legitimacy among [its] own traditional 'highbrow'" audience.

94. For more on MoMA's official response to the program, see Spigel, *TV by Design*, 170–71. For more on the museum's forays into children's television, see Michelle Harvey, "Through the Enchanted Gate: The Modern on TV," *MoMA* 4, no. 7 (September 2001): 27–29.

95. For more on MacAgy's understanding of the incompatibility of high art and popular culture, see Douglas MacAgy, "Fine and Commercial Arts Redefined," *College Art Journal* 9, no. 4 (Summer 1950): 406–11. For an assessment of the Television Project as seen through the holdings of the Museum of Modern Art Archives, see Michelle Elligott, "Modern Artifacts 8: The Art of Broadcasting," *Esopus*, no. 15 (Fall 2010): 148–61.

96. Griffith, quoted here from an internal memo written in 1952, would later modify his view of television. The discussion of the proposed MoMA television library owes a debt to Lynn Spigel, "Our TV Heritage: Television, the Archive, and the Reasons for Preservation," in *A Companion to Television*, ed. Janet Wasko (Malden, MA: Blackwell, 2005), 74–77.

97. As early as 1952, in a letter to MoMA director René d'Harnoncourt, board president Nelson Rockefeller proposed a retrospective of television's finest programming. For more on this, see ibid., 75. Also see *Television U.S.A.: 13 Seasons* (New York: The Museum of Modern Art, 1962). The formation of the Television Archive of the Arts was widely publicized by MoMA, and there was thus significant national coverage. See, for example, "Preserving Our Artistic Heritage," *TV Guide*, July 1, 1967, 23–24.

98. See Jonathan Crary, *Techniques of the Observer: On Vision and Modernity in the Nineteenth Century* (Cambridge, MA: MIT Press), 1990.

99. Ibid., 23.

100. Ibid., 20.

101. Marc Chagall, *Chagall by Chagall* (New York: Harry N. Abrams, 1978), 113.

102. Crary, *Techniques of the Observer*, 20.

103. John Alan Farmer, *The New Frontier: Art and Television, 1960–65* (Austin: Austin Museum of Art, 2000), 24.

104. Ibid.

105. For an early summation of these criticisms, see Rolf B. Meyersohn, "Social Research in Television," in *Mass Culture: The Popular Arts in America*, ed. Bernard Rosenberg and David Manning White (Glencoe, IL: Free Press, 1957), 346.

106. Günther Anders, "The Phantom World of TV," *Dissent* 3 (1956), reprinted in Rosenberg and White, *Mass Culture*, 361.

107. Dwight Macdonald, "A Theory of Mass Culture," *Diogenes* 1, no. 3 (Summer 1953), reprinted in Rosenberg and White, *Mass Culture*, 60.

108. David Joselit, *Feedback: Television against Democracy* (Cambridge, MA: MIT Press, 2007), 18.

109. Joselit writes further: "The television miracle is that we grow to love our discipline as consumers, and to mistake the lively world of things as a social, even a democratic, world in which we 'vote' our preferences by buying them. The melancholy side of television monitoring is the reversal of the roles it perpetually replays: the commodity's animation leads to human stasis, to viewers sitting quietly in darkened rooms everywhere." Ibid., 26.

110. *Outer and Inner Space*, Warhol's first double-projection film, explored the relationship between the material and television worlds.

111. On Warhol's "artistic love story with television," see Judith Benhamou-Huet, ed., *Warhol TV* (Paris: La Maison Rouge, 2009).

112. Rosalind Krauss, "Video: The Aesthetics of Narcissism," *October* 1 (Spring 1976): 50–64. Despite Krauss's somewhat negative assessment, it should be pointed out that video artists also made activist work—exemplified by the projects of Martha Rosler—that addressed broad social and cultural topics, such as race, class, feminism, and the war in Vietnam.

113. Benhamou-Huet, *Warhol TV*, 7.

114. Ibid.

115. For more on Warhol's subversion of television practices, see Spigel, *TV by Design*, 266–68. On Warhol's sexuality in his art, see Maurice Berger, "Andy Warhol's 'Pleasure Principle,'" in Jonathan Binstock, *Andy Warhol: Social Observer* (Philadelphia: Pennsylvania Academy of the Fine Arts, 2000), 22–31. It is important to note, as Warhol's project suggests, that the advent of public television and, later, cable (and local cable-access channels) opened paths for innovative and more democratic television content, some of it more welcoming of difference, conceptual as well as social.

116. Still, video art caught the attention of educational television producers. As early as 1969, WGBH, Boston's educational station, produced a documentary about it, *The Medium Is the Medium*.

117. Of the thousands of national network shows of the period, David Joselit mentions only a handful in *Feedback*. He maintains, without offering any examples, that "television narratives are intensely formulaic: conflicts are established and resolved in tidy units, punctuated by commercial breaks" (*Feedback*, 18). While many programs resort to dramatic or comedic formulas, the best are compelling precisely because of their ability to tease out the nuances and contradictions of characters over many months, if not years. If each half-hour or hour episode attempts to tell a coherent or neat story, serial television often takes a long view as well, exploring the inner lives of characters and their development over time—from Mary Richards's feminist self-realization on *The Mary Tyler Moore Show* (CBS, 1970–77) to Don Draper's tortured battle with psychological demons on the contemporary drama *Mad Men* (AMC, 2007–15).

118. Joselit refers to the promotional nature of celebrity appearances in *Feedback*, 200n56.

119. A cursory list of programs includes *All in the Family* (CBS, 1971–79), *The Bold Ones: The Senator* (NBC, 1970–71), *The David Frost Show* (syndicated, 1969–72), *The David Susskind Show* (syndicated, 1958–87), *The Dick Cavett Show* (ABC, CBS, PBS, USA, 1968–86), *East Side/West Side* (CBS, 1963–64), *Kukla, Fran and Ollie* (NBC, ABC, PBS, 1947–71), *Like It Is* (WABC, 1968–2011), *Lou Grant* (CBS, 1977–82), *Mary Hartman, Mary Hartman* (syndicated, 1976–77), *The Mary Tyler Moore Show* (CBS, 1970–77), *M*A*S*H* (ABC, 1972–83), *Maude* (CBS, 1972–78), *The Phil Donahue Show* (syndicated, 1970–96), *Playhouse 90* (CBS, 1956–60), *The Richard Pryor Show* (NBC, 1977), *Saturday Night Live* (NBC, 1975–present), *See It Now* (CBS, 1951–58), *The Smothers*

Brothers Comedy Hour (CBS, 1967–69), *Soul Train* (syndicated, 1971–2006), and *Westinghouse Studio One* (CBS, 1948–58).

120. Among other such figures were the musical comedy duo the Smothers Brothers, the comedian and actor Andy Kaufman, and the producer and talk-show host David Susskind. See David Bianculli, *Dangerously Funny: The Uncensored Story of* The Smothers Brothers Comedy Hour (New York: Simon and Schuster, 2009); Florian Keller, *Andy Kaufman: Wrestling with the American Dream* (Minneapolis: University of Minnesota Press, 2005); and Stephen Battaglio, *David Susskind: A Televised Life* (New York: St. Martin's, 2010).

121. Tom Shales, "Serling's 'Patterns' an Icon of Lost Era," *TV Week*, April 27, 2008, www.tvweek.com/news/2008/04/serlings_patterns_an_icon_of_l.php. A number of *Twilight Zone* episodes also promoted themes critical of corporate life.

MODERN ART AND EARLY AMERICAN TELEVISION

A CULTURAL TIMELINE

Maurice Berger

1934

The Federal Communications Commission (FCC) is created to regulate use of the broadcast spectrum, including radio and television, and all interstate telecommunications.

1936

Number of television sets in the United States: 200.

An in-house report at the Museum of Modern Art (MoMA) in New York determines that since 1930, the museum has "arranged and prepared" more than 100 radio broadcasts on modern art.

1937

The Columbia Broadcasting System (CBS) starts developing its television division.

William S. Paley, founder and president of the CBS radio and television networks, joins the board of trustees of the Museum of Modern Art.

The National Broadcasting Company establishes the NBC Symphony Orchestra, conducted by Arturo Toscanini.

NBC Symphony Orchestra, 1937. The network's house orchestra, often conducted by the celebrated Arturo Toscanini, was renowned in its day and represented a serious investment in cultural programming. It offered weekly live broadcasts on the radio and, beginning in 1948, television.

1939

1940

"WHAT WE ARE DOING IS SATISFYING THE AMERICAN PUBLIC. THAT'S OUR JOB. I ALWAYS SAY WE HAVE TO GIVE MOST OF THE PEOPLE WHAT THEY WANT MOST OF THE TIME. THAT'S WHAT THEY EXPECT FROM US."

WILLIAM S. PALEY, PRESIDENT OF CBS

The Radio Corporation of America station W2XBS, transmitting from New York, launches the industry's first regular schedule of television service, to 4,000 sets in the area. In April, it broadcasts President Franklin Roosevelt's inauguration of the New York World's Fair; later that year, it is the first station to broadcast a major league baseball game.

DuMont, RCA, and General Electric begin producing television sets for consumers.

Art in Our Time, an exhibition and catalogue celebrating the tenth anniversary of the Museum of Modern Art, helps popularize avant-garde art.

In conjunction with *Art in Our Time*, MoMA and NBC produce the first television broadcast by an American museum.

CBS partners with the Metropolitan Museum of Art in New York to explore new broadcast formats and color transmission.

The American poet Charles Henri Ford founds the Surrealist magazine *View* in New York. Over the next two decades, Surrealism emerges as an abiding influence on avant-garde and visual culture in the United States, including film and television. This influence entails not only iconography—imagery that plumbs the subconscious—but also Surrealism's political and social themes.

William S. Paley, president of CBS, c. 1939.

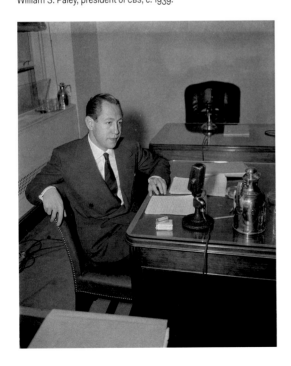

1941

1942

"THE HUMAN BRAIN MUST CONTINUE TO FRAME THE PROBLEMS FOR THE ELECTRONIC MACHINE TO SOLVE."

DAVID SARNOFF, CHAIRMAN OF NBC

The first George Foster Peabody Awards for excellence in radio broadcasting are announced.

Number of television sets manufactured in the United States: 7,000.

The FCC authorizes commercial television.

Both CBS and NBC produce regularly scheduled programming for approximately fifteen hours per week.

The Metropolitan Museum of Art joins the New York CBS affiliate to produce experimental programs that introduce its collections to a local television audience.

André Breton organizes and Marcel Duchamp designs the exhibition *First Papers of Surrealism* in New York.

Alfred H. Barr Jr., *Art in Our Time*, The Museum of Modern Art, New York, 1939.

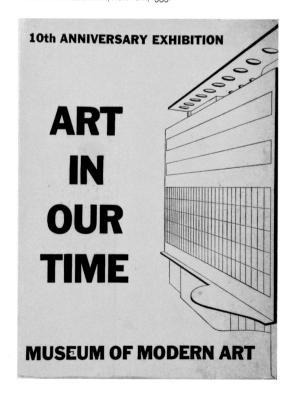

George Foster Peabody Medal

1943

The American Broadcasting Company (ABC) is founded.

WRGB, in Schenectady, New York, broadcasts the first complete opera on television, Engelbert Humperdinck's *Hansel and Gretel*.

1944

The Museum of Modern Art hosts monthly meetings of the American Television Society.

1945

Nine commercial TV stations are in operation in the United States.

Jackson Pollock, *Full Fathom Five*, 1947. Oil on canvas with nails, tacks, buttons, key, coins, cigarettes, matches, etc., 50 ⅞ × 30 ⅛ in. (129.2 × 76.5 cm). The Museum of Modern Art, New York.

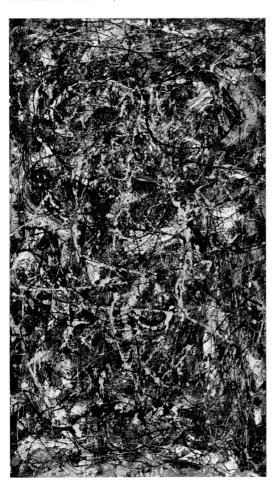

Abstract Expressionism

Jackson Pollock creates the first Drip painting—a key moment in the evolution of Abstract Expressionism. Influenced by earlier avant-garde movements, such as Cubism, Expressionism, and Surrealism, Abstract Expressionist painting and sculpture value spontaneity and improvisation, and especially emphasize process. Even when depicting images based on visual realities, the Abstract Expressionists favor a highly abstracted mode.

1946

The Academy of Television Arts & Sciences is founded.

RCA television sets sell for $225 to $350, as much as 12 percent of the average yearly salary in the United States.

Jon Gnagy, an advertising art director and self-taught artist, offers weekly drawing lessons on NBC's *You Are an Artist*.

Peter Goldmark, an engineer working for CBS, demonstrates his color television system to the FCC.

The exhibition *14 Americans* at the Museum of Modern Art promotes modern painting and sculpture in the United States.

1947

Premieres of NBC's *Kraft Television Theatre*, and of CBS's *Westinghouse Studio One* the following year, usher in a golden age of high-quality dramatic programming on television. More than a dozen dramatic anthology series begin over the next decade, including *Actors Studio* (ABC, CBS), *Pulitzer Prize Playhouse* (ABC), and *The United States Steel Hour* (CBS).

Kinescope—recording by filming from a video monitor—is introduced to preserve TV broadcasts for later use.

First US president to address the public on television: Harry Truman.

First World Series television broadcast, in the New York area: the New York Yankees against the Brooklyn Dodgers.

First network children's show: *Small Fry Club* (DuMont).

Paul Rand's *Thoughts on Design* is published; it has a significant impact on advertising, print, and broadcast graphic design.

1948

Number of households with television sets in the United States: 172,000.

The FCC institutes a partial freeze on new television licenses, resulting in very limited local access to the medium in its formative years. By 1952, when the freeze is lifted, the FCC has issued only 100 new licenses.

The Peabody Awards for television are introduced.

The four national television networks— ABC, CBS, DuMont, and NBC—begin full-time evening programming. Thirty-six commercial television stations nationwide are broadcasting, in nineteen American cities.

The Chicago-based children's program *Kukla, Fran and Ollie* (which launches nationally on NBC), its humor derived from satire and sophisticated wit rather than slapstick comedy, is the first to be equally popular with youngsters and adults.

The Ed Sullivan Show (CBS), television's most successful prime-time variety hour, premieres. Over its twenty-three-year run, the program serves as an early and reliable forum for female, African American, and Hispanic singers, actors, and comedians, despite Sullivan's ongoing battles with conservative sponsors. For viewers of color, these performances are a source of pride—a regular dose of validation from a mainstream culture in which invisibility and stereotypes are the norm. For all viewers, these appearances demonstrate the promise and desirability of integration by presenting professionals interacting as equals, whatever their race.

Cable television is introduced to facilitate the medium's reach into mountain and rural areas.

RCA model 630-TS television, the first mass-produced TV set, 1946–47.

1949

"THE MAIN PREMISES
OF WESTERN
ART HAVE AT LAST
MIGRATED TO
THE UNITED STATES,
ALONG WITH THE
CENTER OF GRAVITY
OF INDUSTRIAL
PRODUCTION AND
POLITICAL POWER."

CLEMENT GREENBERG,
"THE DECLINE OF CUBISM,"
PARTISAN REVIEW

"[IT] LOOKS LIKE
SCRAMBLED EGGS."

PRESIDENT HARRY TRUMAN
TO REPORTERS ON MODERN PAINTING

The first Emmys were awarded at a ceremony of the Academy of Television Arts & Sciences on January 25, 1949. The statuette was designed by Louis McManus, a television engineer.

CBS's Douglas Edwards anchors the first nightly news program.

CBS chairman William Paley attends a meeting of the Television Committee of the Museum of Modern Art to discuss the possibility of producing collaborative programming.

In its annual report, ABC burnishes its high-culture image by celebrating its broadcasts of classical music performances from the Metropolitan Opera and Carnegie Hall in New York.

Hal Zamboni's "Influence of Modern Art on Design and Typography" investigates the impact of major avant-garde movements—notably Cubism, Dada, and Surrealism—on American corporate design. These inform not just television public relations campaigns, but the look, sensibility, and content of on-air art and programs as well.

The art critic Harold Rosenberg attacks mass culture as an oppressive force that alienates the individual and stifles artistic creativity.

The first Emmy Awards are announced by the Academy of Television Arts & Sciences.

Fortune magazine calls television "the most dynamic single element in the American economy."

Sears, Roebuck sells its first television sets via its mail-order catalogue.

The veteran Yiddish theater actress Molly Picon hosts a variety show on ABC.

Over the next twenty years, variety programs such as *Arthur Godfrey and His Friends* (CBS), *The Dinah Shore Show* (NBC), and *The Tonight Show* (NBC) routinely book African American and female entertainers.

The Goldbergs, a weekly comedy-drama series created by the actress Gertrude Berg, premieres on CBS. The show, which centers on a Jewish American family in New York, announces an era of greater acceptance of Jewish characters on American television.

Still from *The Goldbergs*, c. 1950.

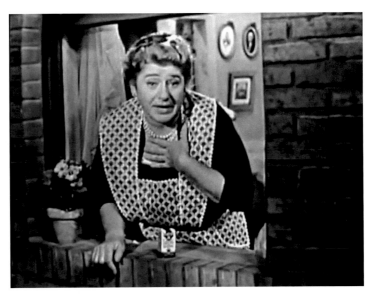

"ALTHOUGH TELEVISION MAY NOT REACH HUGE AUDIENCES AT PRESENT, IT SEEMS WORTHWHILE FOR A MUSEUM TO FAMILIARIZE ITSELF WITH THE MEDIUM. . . . This should put the museum in a position of a certain amount of authority in the field."

IN-HOUSE REPORT,
MUSEUM OF MODERN ART

"CUBISM AIMS TO DESTROY BY DESIGN DISORDER. FUTURISM AIMS TO DESTROY BY A MACHINE MYTH. DADAISM AIMS TO DESTROY BY RIDICULE. Expressionism aims to destroy by aping the primitive and the insane. . . . Abstraction aims to destroy by denial of reason. . . . Abstraction, or non-objectivity . . . was spawned as a communist product [that] has brought down this curse upon us; who has let into our homeland the hordes of germ carrying art vermin."

CONGRESSMAN GEORGE A. DONDERO,
SPEECH TO THE US HOUSE OF
REPRESENTATIVES

Leave It to the Girls (NBC, ABC) is television's first women's advocacy show.

The Museum of Modern Art participates in television programs on average once every two weeks.

The Museum Council of the Brooklyn Museum appoints a television committee.

In her *New York Times* review of an Art Directors Club exhibition at the Museum of Modern Art, the art critic Aline Bernstein Louchheim (later Saarinen) singles out Ben Shahn's abstract art in a CBS advertising campaign as setting a higher aesthetic standard for the industry.

An editorial in *Broadcasting* magazine alleges widespread communist influence in the domestic radio and television industries.

A comic skit on *The Admiral Broadway Revue* (then on NBC) opens onto a huge modernist painting, suggesting both fascination and discomfort with the avant-garde. The cast, bemused by the esoteric object, breaks into song: "Modern works of art / Take first place in our heart, / And this is the museum / Where we all come to see 'em."

Number of households with television sets in the United States: 5,030,000.

The Chicago Fair introduces a "television home," featuring walls that allow the TV set to be seen from every room.

First television station owned by an educational institution: WOI, Iowa State College (now University), Ames.

The Museum of Modern Art participates in television programs on average once a week.

Beginning in the late 1950s and continuing well into the 1960s, scores of American television shows feature appearances by avant-garde visual artists.

Over the next two decades, major art exhibitions in New York, Los Angeles, and other cities help introduce and disseminate modern art in the United States.

The CBS design campaign, directed in the 1950s by William Golden, becomes one of the most respected and celebrated of any American corporation.

Hans Namuth's iconic film of Jackson Pollock painting is among the earliest works to celebrate the complexity, precision, and exuberance of his process. It sets the stage for numerous efforts by television network news and cultural affairs programs to examine the work and practices of contemporary American avant-garde artists.

The Philco Television Playhouse (NBC) broadcasts the hourlong teleplay *The Life of Vincent van Gogh*.

1951

The networks—ABC, and particularly CBS and NBC—commence a two-decade-long program of employing leading artists, designers, and photographers to create on-air art and advertising campaigns.

The African American musical idiom of jazz, with its rhythmic, improvisatory, and virtuoso style, inspires Abstract Expressionists and other avant-garde movements. American television also feels its impact, producing jazz-oriented programs—such as *The Subject Is Jazz* (NBC), *Timex All-Star Jazz Show* (CBS), and *Playboy's Penthouse* (syndicated)—that feature stage sets and advertising with a "cool" modernist aesthetic.

In a series of design exhibitions throughout the decade, the Museum of Modern Art educates the public—and corporations—about the virtues of modern design.

Throughout the 1950s, network cultural and public affairs programs explore and debate avant-garde American art.

New technologies make transcontinental live television possible.

The National Association for the Advancement of Colored People speaks out against two situation comedies it deems offensive: *The Beulah Show* (ABC), about a black maid and the suburban white family she serves, and *The Amos 'n Andy Show* (CBS), about a dialect-talking, self-deprecating businessman and his zany, shiftless business partner.

During TV's early years, women routinely headline as actors, performers, and hosts (though less so as writers, directors, and producers) on such important programs as *I Love Lucy* (CBS), *The Donna Reed Show* (ABC), and *The Adventures of Ozzie and Harriet* (ABC). Rarely are their characters shown to be independent, their lives closely bound up instead with husbands and families.

Networks offer a total of twenty-seven hours of children's programming per week, affirming its ever-increasing role as an educational tool.

The San Francisco museum curator Allon Schoener produces the series *Art in Your Life* for the local NBC affiliate to "make art understandable and to demonstrate its importance" to a general television audience.

The CBS eye logo makes its on-air debut.

NBC president Sylvester "Pat" Weaver organizes Operation Frontal Lobes, an initiative devoted to art and science programming.

The anthology *The Dada Painters and Poets*, edited by Robert Motherwell, is published; it helps popularize the esoteric movement in the United States.

Installation view, *Good Design*, Museum of Modern Art, 1951. The Museum of Modern Art, New York.

Still from *I Love Lucy*, CBS, c. 1951.

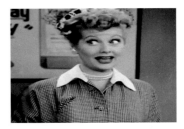

1952

"BECAUSE OF THE PRIMARILY VISUAL NATURE OF TELEVISION BROADCASTING, A NEW FIELD WITH STRONG AND FAR-REACHING POTENTIAL HAS EMERGED FOR THE GRAPHIC ARTIST AND CRAFTSMAN."

SYLVESTER "PAT" WEAVER, PRESIDENT OF NBC

"TELEVISION WILL BE TO THE VISUAL ARTS WHAT THE PRINTED PAGE WAS TO THE LIBERAL ARTS AND SCIENCES AND TO MOST OF THE OTHER AREAS OF KNOWLEDGE AND ACHIEVEMENT WHICH ARE EFFECTIVELY COMMUNICATED THROUGH WORDS."

JAMES SHIPLEY, PROFESSOR OF ART, UNIVERSITY OF ILLINOIS, "HOW TELEVISION CAN SERVE THE UNIVERSITY"

A prototype portable television is introduced.

The first Congressional hearings on television violence are held.

The *Today* show premieres on NBC.

The Surrealist painter Salvador Dalí appears on the quiz show *What's My Line?* (CBS).

CBS Television City studios, with a sleek modernist design, open in Los Angeles.

The Ernie Kovacs Show premieres on NBC. Adapting an avant-garde sensibility suggestive of Dada and Surrealist film and performance, Kovacs's unprecedented program is characterized by ad-libbed routines, experimental video effects, adventurous camera work, and eccentric humor.

The Museum of Modern Art Television Project is established with a grant from the Rockefeller Brothers Fund.

Under the auspices of the MoMA Television Project, co-director Sidney Peterson produces *Architectural Millinery*, the first of a proposed series of short, experimental commercial films for television. It looks at the abstract and formal similarities between hats and rooftops in the urban landscape. A second film by Peterson, *Manhole Covers* (1954), studies similar formal themes. MoMA ultimately rejects the films for broadcast, concluding that they lower the museum's "intellectual level."

The series *Through the Enchanted Gate*, sponsored by the MoMA Television Project and broadcast for two seasons on WNBC, offers "any child within range of a television . . . the best art training possible."

In his *New York Times Magazine* article "Is Modern Art Communistic?" the MoMA director, Alfred H. Barr Jr., rejects the notion of abstract art as inherently ideological, condemning instead the demagoguery of social realist art in Nazi Germany and the Soviet Union. Television networks, paralleling this Cold War rhetoric, embrace modernism as a symbol of democracy and freedom.

Andy Warhol designs title art and advertisements for CBS and NBC. He receives his first Art Directors Club award for his design campaign for *The Nation's Nightmare*, a CBS radio program about teenage drug use.

Salvador Dalí on *What's My Line?* CBS, 1952.

"TELEVISION PROGRAMS OF THE JOHN GNAGY TYPE ARE DESTRUCTIVE TO THE CREATIVE AND MENTAL GROWTH OF CHILDREN
and perpetuate outmoded and authoritarian concepts of education. Creative education is based on each child's individuality, the opportunity to use his own experience and to explore new media and techniques."

COMMITTEE ON ART EDUCATION, SPONSORED BY THE MUSEUM OF MODERN ART

"IT SEEMS TO ME THAT THE MODERN PAINTER CANNOT EXPRESS THIS AGE, THE AIRPLANE, THE ATOM BOMB, THE RADIO, IN THE OLD FORMS OF THE RENAISSANCE OR OF ANY OTHER PAST CULTURE. EACH AGE FINDS ITS OWN TECHNIQUE."

JACKSON POLLOCK

Andy Warhol (cover and label designer), *The Nation's Nightmare*, CBS Radio, 1952. Album cover and vinyl record with paper label.

1953

Color television broadcasting begins.

First noncommercial educational television station in the United States: KUHT, University of Houston.

The weekly magazine *TV Guide* is launched.

Hanna Bloch Kohner, a survivor of Nazi concentration camps, appears on an episode of *This Is Your Life*.

Georg Olden, director of graphic design at CBS, names Andy Warhol one of the top twelve title artists for television.

Winky Dink and You—television's first interactive program—premieres on CBS.

Ray Bradbury's science fiction classic *Fahrenheit 451* associates television with themes of mind control and fascism. Eight years later, Allen Ginsberg creates a poem out of technological noise, titling it "Television Was a Baby Crawling Toward that Deathchamber."

Dada 1916–1923 opens at the Sidney Janis Gallery. The exhibition—organized under the direction of Marcel Duchamp—inspires a new generation of American artists and cultural figures.

The United States Information Agency is established by the State Department to promote internationally, through cultural diplomacy, the anticommunist Cold War ideals of American democracy and capitalism. Throughout the 1950s, the agency exports several traveling exhibitions of modern art, equating it with democracy and freedom—an idea that also motivates television executives, designers, and producers.

1954

Approximately 50 percent of American households have television sets.

The first electronic color television sets sell for $1,000.

First transcontinental color television program: the Rose Bowl Parade. Only 200 sets are able to receive the broadcast.

Networks air the hearings of the House Un-American Activities Committee. The journalist Edward R. Murrow discredits the committee chairman, Senator Joseph McCarthy, on CBS's *See It Now*, dramatically swaying public opinion.

First public television station in the United States: WQED, Pittsburgh.

The Museum of Modern Art director, René d'Harnoncourt, joins the board of trustees of the National Educational Television Association.

The CBS public affairs program *Dimension* devotes an episode to the Museum of Modern Art's twenty-fifth anniversary.

The MoMA Television Project co-director, Sidney Peterson, completes a book-length manifesto, "The Medium," in which he argues for television's egalitarian artistic potential.

The permanent installation of the Louise and Walter Arensberg Collection opens at the Philadelphia Museum of Art. With forty-three works by Marcel Duchamp, the collection introduces his work to a broader public and to a new generation of artists, designers, and producers.

1955

Sales of RCA color television sets increase to 20,000 from 5,000 the previous year.

First Spanish-language television station in the United States: KCOR, San Antonio, Texas.

CBS president Dr. Frank Stanton—a onetime aspiring architect and a collector of avant-garde art—commissions the modernist architect Eero Saarinen to design the network's new corporate headquarters in New York.

The MoMA Television Project co-director, Sidney Peterson, conceives a program for children—*The Invisible Moustache of Raoul Dufy*—and negotiates a production deal among MoMA, NBC, and United Productions of America (UPA), a major Hollywood animation studio.

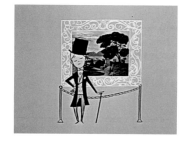

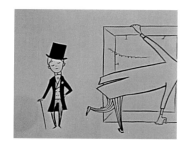

Museum of Modern Art Television Project (co-producer) and NBC (co-producer), in collaboration with United Productions of America (animator), stills from *The Invisible Moustache of Raoul Dufy*, 1955.

1956

The Museum of Modern Art's Television Project is discontinued.

The MoMA director, Alfred H. Barr Jr., appears on the NBC morning program *Home* to explain abstract art to the general public. He is aided by paintings from MoMA's collections—by Marc Chagall, Giorgio De Chirico, Arthur Dove, and Vasily Kandinsky—transported to the network's New York studios.

NBC's public affairs program *Wide Wide World* devotes episodes to the modern dancer Martha Graham and the artists Paul Gauguin, Edward Hopper, Henri Matisse, Robert Motherwell, Pablo Picasso, and Vincent van Gogh.

By the mid-1950s, art and culture previously considered elitist and irrelevant are championed by the mass media— and by the Eisenhower administration (and later the Kennedy and Johnson administrations)—as exemplifying American ideals of freedom and democracy. The ideological repackaging of modern art makes it appealing to a television industry that often promotes itself as a symbol of national pride and freedom and as a generator of aesthetic and technological innovation.

RCA reduces the price of color television sets to $500.

The first wireless remote control and first practical, broadcast-quality videotape system are introduced.

The Nat King Cole Show (NBC) is the first national variety program to be hosted by an African American entertainer. The show airs with few sponsors and is canceled a year later.

NBC's public affairs program *Wisdom* features an interview with Marcel Duchamp.

The Los Angeles–based abstract painter Lorser Feitelson hosts a local Sunday-morning NBC television series, *Feitelson on Art*, in which he discusses contemporary art.

Articles in *Life* magazine promote the idea of television as an educational tool.

A television set serves as the ultimate icon of mass culture in the Pop artist Richard Hamilton's *Just What Is It That Makes Today's Homes So Different, So Appealing?* Over the next twenty years, scores of avant-garde artists use or comment on the medium through its hardware and imagery.

The United States Information Agency withdraws a planned internationally traveling exhibition, *100 American Artists of the Twentieth Century*, because of the presence of what are considered ten politically "unacceptable" leftist participants.

Richard Hamilton, *Just What Is It That Makes Today's Homes So Different, So Appealing?*, 1956. Collage, 10 ¼ × 9 ¾ in. (26 × 25 cm). Kunsthalle Tübingen, Germany.

Gold, onyx, and marble CBS cuff links, c. 1957. CBS porcelain ashtray, c. 1955.

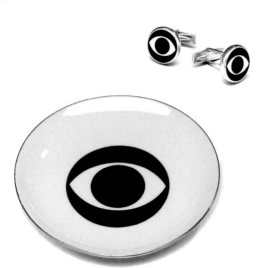

1957

1958

The National Academy of Television Arts & Sciences is founded to support local stations outside Los Angeles.

The Museum of Modern Art co-produces a segment of the CBS News series *Odyssey*, titled "The Revolution of the Eye," that explores how modern art has profoundly changed the way people see and understand the world.

NBC's game show *Twenty One* is canceled after Congressional hearings expose a cheating scandal.

An "Abstract Expressionist" painting by J. Fred Muggs, a chimpanzee and former mascot of NBC's *Today show*, appears on the cover of *Mad* magazine. The United States media's fascination with "chimp artists" reflects a predominantly derisive view of avant-garde art in popular culture. Intentionally or otherwise, associations like this one also reflect a reactionary undercurrent in the culture at large that views modern art in general, and Abstract Expressionism in particular, as alien to American values—a response, perhaps, to the movement's European origins and the perceived preponderance of Jewish artists, critics, curators, and dealers.

In an *ARTnews* essay, "The Legacy of Jackson Pollock," the artist Allan Kaprow argues that Pollock's performance-like working methods suggest a dramatic option for avant-garde artists: "to give up making paintings entirely" in favor of a more direct, physical engagement with the "space and objects of our everyday lives."

In an essay in *Architectural Design*, "The Arts and the Mass Media," the critic Lawrence Alloway, in support of Pop Art, advocates erasing the rigid distinction between "authentic" avant-garde art and "ersatz" media culture.

The International Arts Council of the Museum of Modern Art, in association with the United States Information Agency, mounts a touring exhibition of Abstract Expressionism, *The New American Painting*. In his introduction to the catalogue, the former MoMA director, Alfred H. Barr Jr., advocates the Cold War ideal of modern art as an apolitical paradigm of the openness and freedom of Western democracy.

Graphic Design

The visual campaigns for the major networks reach full force in the 1950s, a period of considerable growth and creativity in graphic design. Postwar economic recovery in the United States stimulates the growth of business and, by extension, the need for strong graphic and advertising campaigns. In this environment, the networks support innovative promotional campaigns by some of the world's most famous graphic designers, including Saul Bass, Paul Rand, Ben Shahn, and Andy Warhol.

The New York School

The New York School is the name given to an informal group of American composers, dancers, musicians, painters, photographers, poets, and sculptors working in the 1950s and 1960s. Taking inspiration from the modern city, these artists deemphasize the political concerns of art of the 1930s and 1940s in favor of an exploration of the personal, drawing inspiration from psychology and Existentialist philosophy as well as Surrealism, Dada, and other avant-garde art movements. The group includes the composers John Cage and Morton Feldman; the writers William S. Burroughs, Allen Ginsberg, Jack Kerouac, and Frank O'Hara; Judson Dance Theater; and many Abstract Expressionist painters and sculptors.

Cover, *Mad* magazine, March 1958.

1959

"CONTEMPORARY MAN COMMONLY FINDS HIS LIFE HAS BEEN EMPTIED OF MEANING, THAT IT HAS BEEN TRIVIALIZED. HE IS ALIENATED FROM HIS PAST, FROM HIS WORK, FROM HIS COMMUNITY. . . .

It is widely assumed that the anxiety generated by modern civilization can be allayed, as nerves are narcotized by historical novels, radio or television programs and all the other ooze of our mass culture."

BERNARD ROSENBERG,
"THE ISSUES JOINED:
MASS CULTURE IN AMERICA"

"FACED WITH THE NEW FACT OF CONSUMER ADVERTISING, WE TRIED TO CONSIDER IT VERY CAREFULLY. . . .

We didn't think we should imitate the advertising of motion pictures or theater, because it was neither of these things. . . . We considered it an opportunity to make a new kind of advertising for a new medium."

WILLIAM GOLDEN, CREATIVE DIRECTOR
OF ADVERTISING AND SALES PROMOTION,
CBS TELEVISION

Number of households with television sets in the United States: 43,950,000.

A Gallup survey reports that 67 percent of Americans believe that television commercials make "untruthful arguments."

The Twilight Zone premieres on CBS.

Promoting its production of *Hamlet*, CBS publishes a deluxe, limited-edition teleplay with illustrations by Ben Shahn.

Allan Kaprow produces his first public Happening, at the Reuben Gallery in New York. Drawing from various sources—including Jackson Pollock's painting methods and the composer John Cage's ideas on chance in art—Kaprow's Happenings are conceived as partly choreographed events in which objects, performers, and audience spontaneously interact.

The CBS Television art director William Golden dies. He is succeeded by Lou Dorfsman, previously the art director of CBS Radio.

The work of artists associated with the New American Cinema—Jordan Belson, Stan Brakhage, Shirley Clarke, Bruce Conner, Robert Frank, Ken Jacobs, Jonas Mekas, Stan VanDerBeek—transgresses traditional film style and subject matter through a variety of new techniques, from unconventional film speeds to the use of special lenses. Some of these filmmakers will go on to collaborate with—and, indeed, influence—network television producers, directors, designers, and writers.

Ben Shahn (artist) and William Golden (art director), promotional publication of *Hamlet* teleplay, CBS, 1959.

"WE GIVE THE MOST CAREFUL ATTENTION TO ALL ASPECTS OF DESIGN. WE BELIEVE THAT WE SHOULD NOT ONLY BE PROGRESSIVE BUT LOOK PROGRESSIVE. WE AIM AT EXCELLENCE IN ALL THE ARTS, INCLUDING THE ART OF SELF-EXPRESSION."

DR. FRANK STANTON,
PRESIDENT OF CBS TELEVISION

1960

Number of television sets in the United States: 45,750,000.

The first CLIO Awards are presented for excellence in television advertising.

The broadcast of four debates between presidential candidates Richard Nixon and John F. Kennedy transforms the role of television in American politics.

New Media—New Forms in Painting and Sculpture, a two-part exhibition at the Martha Jackson Gallery, New York, helps popularize Dada and the emerging Pop Art aesthetic.

1961

CBS proposes a scholarly journal devoted to television.

Television Age magazine singles out the CBS eye logo as "one of the most familiar trademarks in American life."

Salvador Dalí creates a Surrealist canvas with a paint gun on *The Ed Sullivan Show*.

Avant-garde artists featured on network and public television programs: the architects Philip Johnson and Louis Kahn and the photographer Edward Steichen.

The advertising executive Stephen Baker argues in his book *Visual Persuasion* that women like visually oriented ads with "gay, colorful" modern paintings that instill a sense that they "are being 'talked up' to" and "are smart and knowing and possess good taste." As the cultural historian Lynn Spigel will later note, during the postwar period, women become the focus of advertising and television programming built on modernist forms and principles.

In a speech to the National Association of Broadcasters, the FCC chairman Newton N. Minow declares television a "vast wasteland."

Televised presidential debate: Richard Nixon and John F. Kennedy, 1960.

1962

"THE VERY ACT OF DESIGNING EXPOSES ELEMENTS THAT ARE INCONSISTENT AND MUST OBVIOUSLY BE REJECTED. WHEN [THE DESIGNER] IS IN CONTROL OF THESE ELEMENTS, HE CAN USUALLY PRODUCE AN ACCEPTABLE DESIGN. When somebody else controls them, the best he can produce is a counterfeit: that is why at some stage of his maturity he feels the need to have a voice in the content itself."

WILLIAM GOLDEN, "THE VISUAL ENVIRONMENT OF ADVERTISING"

Eighty million Americans watch a televised White House tour led by First Lady Jacqueline Kennedy.

AT&T launches Telstar 1, the first satellite to send television signals, revolutionizing TV news programming and live broadcasting.

Paul Rand, experimenting with letterforms that will remain readable even with poor television reception, designs ABC's trendsetting Minimalist logo.

Avant-garde artists featured on network and public television programs: Jean Arp, Marc Chagall, Jacques Lipchitz, Frank Lloyd Wright.

The Museum of Modern Art organizes *Television U.S.A.: 13 Seasons*, a retrospective of golden age programs and television commercials.

Judson Dance Theater is founded, the premier showcase for independent modern dance and performance in New York. The collective, based at Judson Memorial Church in Greenwich Village, has a radical impact on the dance world as well as on visual artists, introducing temporal interaction and spectator participation into the experience of avant-garde art.

Philip Leider launches *Artforum* in San Francisco. The glossy monthly, which eventually moves to Los Angeles and then New York, disseminates ideas about avant-garde art to a broader art world and cultural audience.

Norman Rockwell's cover for *The Saturday Evening Post* of a man studying a Pollock Drip painting attests to the continued bewilderment with abstract art among many Americans.

Time, *Life*, and *Newsweek* covers feature Pop Art.

Pop Art

Andy Warhol exhibits his *Campbell's Soup Cans* at the Ferus Gallery in Los Angeles. Sidney Janis organizes the breakthrough exhibition *The New Realists* at his New York gallery, an international survey of Pop Art and related work that helps secure the importance of the new movement. The Pop sensibility, born in the mid-1950s in Great Britain and the United States, draws on themes, imagery, and techniques from popular culture, including advertising, comic books, movies, television, magazines, and newspapers.

Fluxus

Organized by the artist George Maciunas, this movement traces its beginnings to John Cage's experimental composition classes at the New School for Social Research in New York. A Fluxus member, Dick Higgins, describes it as "inter-media," blending literature, performance, film, television, and other artistic disciplines and technologies into complex countercultural works.

Paul Rand (designer), ABC logo, early 1960s.

1963

Television news coverage of the historic March on Washington and nightly news reports on racial violence and strife in the South contribute to a pronounced shift in national public opinion about the civil rights movement.

Grappling with such controversial topics as inner-city blight and neglect, homelessness, bigotry, and drug addiction, the thoughtful, critically acclaimed one-hour drama *East Side / West Side* (CBS) features the first recurring African American character in a nationally broadcast dramatic television series.

Critics assail CBS's top-rated *The Beverly Hillbillies* as symptomatic of a general decline in the quality of television programming.

The networks cancel regular programming for several days to provide continuous coverage of the assassination of President Kennedy.

The *Los Angeles Times* extols the artistic integrity of the best television ads, which have "the courage to say art and commercial in the same breath."

Avant-garde artists featured on network and public television programs: Karel Appel, Alexander Calder, Marcel Duchamp.

Marcel Duchamp's first US retrospective opens at the Pasadena Art Museum, affirming his continued influence on the American avant-garde.

Duchamp appears in the documentary *The Art Show that Shocked America* (presented on the CBS News program *Eyewitness*), celebrating the fiftieth anniversary of the Armory Show.

The artist Nam June Paik has his first solo exhibition, at Galerie Parnass, Wuppertal, West Germany. *Exposition of Television—Electronic Music* features piles of functioning television sets with images distorted by magnets.

1964

The gay activist Randy Wicker appears on *The Les Crane Show.*

The *Today* show's Aline Saarinen becomes the first art critic to appear regularly on an American television program.

Avant-garde artists featured on network and public television programs: Alexander Calder, Stuart Davis, Marcel Duchamp, Alberto Giacometti, Edward Hopper, Roy Lichtenstein, Joan Miró, Henry Moore, Robert Motherwell, Barnett Newman, Georgia O'Keeffe, Larry Rivers, Ben Shahn, David Smith, Jack Tworkov, Andy Warhol, Jane Wilson.

Jazz Images, the first of a series of experimental broadcasts, is produced by the Boston public television station WGBH.

The March on Washington, August 28, 1963.

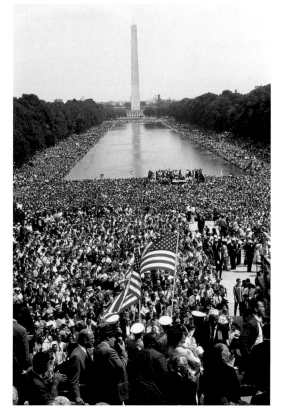

Marcel Duchamp on *The Art Show that Shocked America*, CBS, 1963.

1965

Andy Warhol co-directs the film *Soap Opera* (unfinished), which appropriates the style of television and footage from it.

Life magazine articles on Pop Art and Op Art help familiarize readers with the movements in the United States.

James Thrall Soby, chairman of the Committee on the Museum Collections at the Museum of Modern Art, proposes to establish an archive devoted to television coverage of modern art and artists.

Nam June Paik moves to New York and begins collaborating with the cellist Charlotte Moorman on works that combine video, television hardware, music, and performance.

In the book *Understanding Media*, the theorist Marshall McLuhan declares that "the medium is the message," galvanizing a new generation of video makers experimenting with alternative uses of telecommunications.

The fall season opens with most of NBC'S prime-time schedule produced on color film. CBS follows in 1966, and ABC in 1967.

I Spy (NBC) is the first national TV drama or comedy to feature an African American actor (Bill Cosby) in a leading role that is neither menial nor derogatory.

Programs as varied as *Get Smart* (NBC, CBS), *I Led Three Lives* (syndicated), *I Spy* (NBC), *Mission: Impossible* (CBS), *The Outer Limits* (ABC), *Rocky & His Friends* (ABC), and *Star Trek* (NBC) represent the many network television programs with anticommunist and pro-democracy messages.

Avant-garde artists featured on network and public television programs: Richard Anuszkiewicz, Stan Brakhage, Marisol Escobar, Robert Indiana, Henry Moore, Claes Oldenburg, Robert Rauschenberg, George Rickey, George Segal, Ben Shahn.

Eero Saarinen's CBS Building, known as Black Rock, opens in New York. The thirty-eight-story structure, with interior spaces and furnishings designed by Saarinen and Florence Knoll, is considered one of the city's most prestigious modern skyscrapers.

The Responsive Eye at the Museum of Modern Art examines Op Art. The exhibition focuses on work that explores art's perceptual aspects, including the illusion of movement and the optical interaction of color and form. The news series *CBS Reports* devotes an episode to the exhibition.

The artist Ray Johnson produces a series of collages that consider mass media; of these, *One TV*, addresses the infiltration of television's incessant imagery into modern life.

Eero Saarinen's CBS Building on the cover of *Architectural Record*, July 1965.

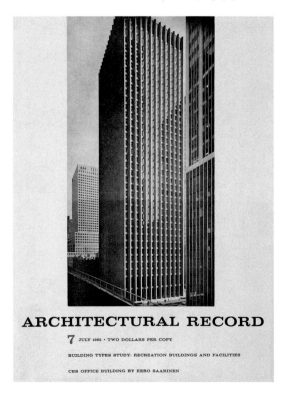

Minimalism

Donald Judd and Robert Morris show early Minimalist works at the Green Gallery, New York. Motivated by such diverse influences as John Cage, Marcel Duchamp, and New Left politics, Minimalism favors simple geometric forms, smooth surfaces, and industrial appearance or fabrication, and overtly rejects the sensuous brushwork and optical effects of Abstract Expressionism. The experience of Minimalism—which calls for spectators to walk onto, through, or into austere objects or stare at flat, unyielding surfaces—blurs the traditional boundaries between art object and viewer.

1966

"COLOR TELEVISION IS ENJOYING A FANTASTIC BOOM. SO IS ART. BOTH ARE INTERRELATED."

ROBERT SARNOFF, CHAIRMAN OF NBC, SPEECH TO FRIENDS OF THE WHITNEY MUSEUM OF AMERICAN ART

A one-hour musical celebration of Harlem, *The Strollin' Twenties*, conceived and produced by Harry Belafonte after reading Langston Hughes's autobiography *The Big Sea*, is broadcast on NBC.

Affirming the medium's power to transform society, the poet and Black Arts Movement founder Amiri Baraka (born Everett LeRoi Jones) declares, "If you give me a television station, we won't need a bloody revolution."

That Girl (ABC), starring Marlo Thomas as an unmarried actress in the big city, breaks from the sitcom stereotype of women as servile housewives and mothers.

Batman (ABC) shows the influence of Pop Art.

Andy Warhol creates cover art for an issue of *TV Guide*, featuring an article about *Get Smart* (NBC, CBS).

The *Life* magazine article "Psychedelic Art" discusses a new sensibility in art that will substantially affect American television broadcast design.

USA Artists, an anthology series featuring avant-garde cultural figures, is produced by New York's public television station.

Avant-garde artists featured on network and public television programs: Willem de Kooning, Jim Dine, Helen Frankenthaler, Charles Frazier, Jasper Johns, Allan Kaprow, Alex Katz, Roy Lichtenstein, Morris Louis, Barnett Newman, Kenneth Noland, Claes Oldenburg, Robert Rauschenberg, James Rosenquist, George Segal, Frank Stella, Andy Warhol.

"Shots from the Underground," a segment of the CBS News program *Eye on New York*, features the work of the avant-garde filmmakers Bruce Conner, Carmen D'Avino, and Ed Emshwiller.

Primary Structures at the Jewish Museum in New York is the first major museum exhibition devoted to Minimalism. The clean, dynamic forms of Minimalist sculpture influence contemporaneous television stagecraft, most notably the sets of the weekly live variety program *The Ed Sullivan Show*.

Harold Rosenberg delivers a lecture at the Jewish Museum in New York titled "Is There a Jewish Art?"

Andy Warhol, interview, *USA Artists*, WNET, 1966.

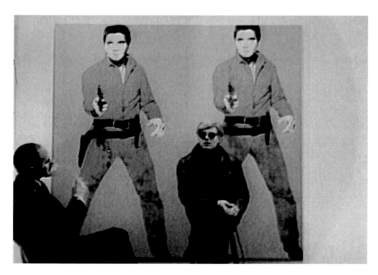

Andy Warhol, *Get Smart* cover for *TV Guide*, March 5, 1966.

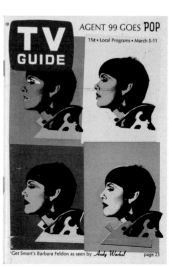

1967

> "THE TELEVISION DOCUMENTARY TODAY CHRONICLES THE EXPRESSIONS AND REACTIONS, BOTH VERBAL AND VISUAL, OF CONTEMPORARY ARTISTS . . .
>
> and provides a new source of documentation for research. The art student can now make use of the best possible original material—the artist himself discussing his work or demonstrating his techniques."
>
> BROCHURE, TELEVISION ARCHIVES OF THE ARTS, MUSEUM OF MODERN ART

> "COMMERCE, INDUSTRY AND THE ARTS ARE, I THINK, ON THE EVE OF A NEW ALLIANCE EVERYWHERE IN OUR COUNTRY. . . .
>
> A business must now show evidence of a regard for the standards of excellence, good taste, and distinction that both inspire and are stimulated by the arts."
>
> DR. FRANK STANTON, PRESIDENT OF CBS

The Vietnam War is the first conflict to be routinely covered on television, the subject of often graphic nightly news reports.

Sony markets a portable videotape recorder, revolutionizing television news and the emerging video art movement.

The Corporation for Public Broadcasting is established, and authorizes federal funding for public TV stations.

Over the next few years, *NBC Experiment in Television* features documentaries on intellectual and artistic cultural figures, teleplays by cutting-edge writers—John Guare, John Hawkes, Harold Pinter, and Tom Stoppard, to name a few—and avant-garde films such as *The Cube*, a surrealistic comedy-drama written and directed by Jim Henson.

The Experimental Television Workshop is launched at KQED, San Francisco's public television station.

A *Life* magazine article describes public television as an "oasis" in the "wasteland" of commercial broadcasting.

CBS News airs a lurid documentary on homosexuality.

WGBH in Boston initiates an artist-in-residence program. The station produces an anthology series—*What's Happening Mr. Silver?*—that juxtaposes abstract imagery with footage of everyday life.

The Museum of Modern Art inaugurates a Television Archive of the Arts.

James Rosenquist completes a sequence of four paintings that, evoking the shape and surface of television screens, satirize the aesthetic purity and formalism of Color Field painting.

James Rosenquist, *Aspen, Colorado*, 1966. Oil on canvas, 48 × 62 in. (122 × 57 cm).

1968

Television coverage of the assassinations of Dr. Martin Luther King Jr., in April, and Senator Robert F. Kennedy, in June, reaffirms the medium as the dominant source of news and information in the United States.

CBS newsman Walter Cronkite visits Vietnam and returns to do a special program on the war. Declaring the conflict a stalemate and advocating a negotiated peace, Cronkite helps shift public opinion on US involvement in the war.

Julia—a situation comedy built around a contemporary African American character—debuts on NBC. While the show is extremely popular, civil rights advocates and black viewers criticize it for its lighthearted view of race relations and its unwillingness to represent the problems faced by real African Americans.

Andy Warhol directs "The Underground Sundae," a one-minute television commercial for Schrafft's restaurants, in the style of his countercultural movies.

Gathering from the visual style and sensibilities of Pop, Op, psychedelic art, Happenings, and modern fashion design, the innovative variety program *Rowan & Martin's Laugh-In* premieres on NBC.

The painter Edward Biberman hosts the weekly interview show *Dialogues on Art* on KNBC in Los Angeles.

"Of Black America"—a print ad for the series of that title, by the CBS television art director Lou Dorfsman, with an American flag superimposed on the face of an African American man—is widely considered a design icon.

A Museum of Modern Art exhibition, *The Machine as Seen at the End of the Mechanical Age*, includes video.

1969

Some 600 million people around the world watch the first television transmission from the moon.

The Brady Bunch (ABC), a sitcom about a large blended American family, features a modernist architect father, Mike Brady.

First exhibition devoted entirely to video art: *Television as a Creative Medium*, Howard Wise Gallery, New York.

First broadcast television program about artists' use of television: *The Medium Is the Medium*, WGBH, Boston. It features the work of Allan Kaprow, Nam June Paik, Otto Piene, James Seawright, Thomas Tadlock, and Aldo Tambellini.

New York solo exhibitions by Bruce Nauman (Leo Castelli Gallery) and Dennis Oppenheim (John Gibson Gallery) feature videotapes.

The Art Workers' Coalition is founded in New York. The group calls for exhibition opportunities for artists of color and women artists, and expanded legal rights for all artists. It inspires other art world collectives, political associations, alternative exhibition spaces, and service organizations.

Nam June Paik and Charlotte Moorman, *TV Bra for Living Sculpture*, 1969. Performance at Hauswedell & Nolte, Hamburg.

Allan Kaprow, still from "Hello," *The Medium Is the Medium*, WGBH, 1969.

1970

"WE HAVEN'T GOT
JUST A COMMERCIAL.
WE'VE ACQUIRED
A WORK OF ART."

FRANK G. SHATTUCK, PRESIDENT
OF SCHRAFFT'S, ON WARHOL'S
"THE UNDERGROUND SUNDAE"

The Public Broadcasting Service (PBS) network is established.

Over the next three years, high-quality programming—*All in the Family* (CBS), *The Bold Ones: The Senator* (NBC), *M*A*S*H* (CBS), *The Great American Dream Machine* (PBS)—advances television's artistic excellence.

The Mary Tyler Moore Show (CBS), with a single working woman as its title character, proposes a new, positive model for female characters on broadcast television, as well as a high standard for situation comedies.

Covering such taboo topics as homosexuality, domestic violence, and abortion, *The Phil Donahue Show*, a daytime talk program, goes into national syndication.

In "Expanded Cinema," a manifesto advocating "revolutionary" aesthetic experimentation with new media, Gene Youngblood argues that "commercial entertainment works against art experimentation, exploits the alienation and boredom of the public, by perpetuating a system of conditioned response to formulas."

Vision and Television, a major exhibition of video art, opens at the Rose Art Museum in Waltham, Massachusetts.

Still from *The Mary Tyler Moore Show*, CBS, 1970.

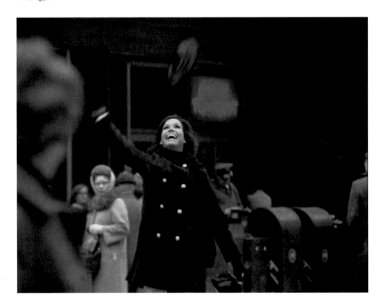

PBS logo, 1970.

1971

In an episode of *All in the Family* (CBS), the protagonist, Archie Bunker, learns that an old friend—a pro football player—is gay.

PBS'S prescient twelve-part series *An American Family*, a precursor to "reality television," follows the day-to-day lives of the Loud family of Santa Barbara, California. During filming, the family visits an Andy Warhol retrospective at the Whitney Museum of American Art in New York. Lance Loud, a son who is gay, will later joke of his appearance on the series, "I was in *Chelsea Girls II*, the sequel," referring to Warhol's 1966 underground film.

On an episode of *The David Susskind Show* (syndicated), the lesbian activist Barbara Gittings proclaims that "homosexuals today are taking it for granted that their homosexuality is not at all something dreadful."

In their manifesto "Guerrilla Television," artists and activists promote an alternative video movement to counter what they see as an aesthetically bankrupt and commercially corrupt broadcast medium.

The Kitchen is founded in New York as a locus of experimentation in video and, later, dance and music.

1972

First widely played video game: Pong.

Half of all homes in the United States have color television.

That Certain Summer, a made-for-TV movie on ABC, features Hal Holbrook and Martin Sheen as a gay couple.

The "ghetto sitcom" *Sanford and Son* (NBC) is the first mainstream situation comedy to feature a mostly black cast since *The Amos 'n Andy Show* in the 1950s.

Maude, a watershed social-issues situation comedy on CBS, stars Bea Arthur as an outspoken feminist.

The Federal Communications Commission supports the idea of "media democracy" by requiring cable television companies to provide free public-access channels—stations that often function as distribution and exhibition sites for experimental video makers.

A report from the Office of the Surgeon General of the United States cites a link between viewing television violence and antisocial behavior.

A broadcast production and postproduction studio for video artists, the TV Lab is inaugurated at New York's public television station, WNET.

Still from *An American Family*, PBS, 1971.

Still from the video game Pong, 1972.

"MY MOVIES HAVE BEEN WORKING TOWARDS TV. IT'S THE NEW EVERYTHING. NO MORE BOOKS OR MOVIES. JUST TV."

ANDY WARHOL

"HOLLYWOOD. 1989. AVANT-GARDE FILMMAKER ANDY WARHOL JR. TODAY SHOCKED THE ENTIRE FILM WORLD WITH HIS NEW MOVIE, ORGY GIRL, which features a love scene between two fully clothed people. In his defense, Warhol said the clothed scene was done in excellent taste and, besides, it will only be shown in foreign markets."

ITEM ON "NEWS OF THE FUTURE,"
ROWAN & MARTIN'S LAUGH-IN

1973

Television buying in the United States hits a peak: 17,368,000 sets sold in one year.

Andy Warhol appropriates the soap opera format in a series of experimental videos for television.

1974

A founding text of television studies, Raymond Williams's *Television: Technology and Cultural Form*, is published.

The CBS situation comedy *Rhoda* centers on a positive fictional portrait of an American Jewish woman.

The Museum of Modern Art hosts "Open Circuits: An International Conference on the Future of Television." Virtually ignoring commercial and public television—and the museum's own history—the hallmark symposium anoints video art with high-art status.

Conceptualism

A pioneering group exhibition of Conceptual Art, *o Objects, o Paintings, o Sculptures*, is mounted by the New York dealer Seth Siegelaub. Conceptualism questions the role of art as precious commodity, as well as its place within traditional art world institutions. Influenced by Dada and especially by John Cage, Marcel Duchamp, and Fluxus, the movement emphasizes concepts or ideas over traditional aesthetic and material concerns. In some cases, Conceptualism entails no art object per se, but exists solely as text or ephemeral experience.

1975

> "THE FEW TIMES IN MY LIFE WHEN I'VE GONE ON TELEVISION, I'VE BEEN SO JEALOUS OF THE HOST … THAT I HAVEN'T BEEN ABLE TO TALK. AS SOON AS THE TV CAMERAS TURN ON, ALL I CAN THINK IS, 'I WANT MY OWN SHOW … I WANT MY OWN SHOW.'"
>
> ANDY WARHOL

> "A WHOLE DAY OF LIFE IS LIKE A WHOLE DAY OF TELEVISION. … AT THE END OF THE DAY THE WHOLE DAY WILL BE A MOVIE. A MOVIE MADE FOR TV."
>
> ANDY WARHOL

The consumer video cassette recorder (VCR) is introduced in the United States.

The ABC situation comedy *Hot l Baltimore*, adapted from an off-Broadway play by Lanford Wilson, features the first gay male couple on serial television.

The Museum of Broadcasting is founded in New York by the CBS head, William S. Paley.

The Whitney Museum of American Art presents *Projected Video*, the first museum exhibition to use the recently developed Advent VideoBeam projector.

The Association of Independent Video and Filmmakers is founded.

Until his death in 1987, Andy Warhol continually uses television in his work. He appears in commercials and on talk and public affairs programs. He produces three segments for NBC's popular variety program *Saturday Night Live* and three cable television series—*Fashion, Andy Warhol's T.V.*, and *Andy Warhol's Fifteen Minutes* (MTV)—and appears as himself on *Saturday Night Live* and ABC's hit comedy *The Love Boat*.

Andy Warhol, *The Marx Brothers*, 1980. Screenprint on paper, 40 × 32 in. (101.6 × 81.3 cm). The Jewish Museum, Gift of Lorraine and Martin Beitler, 2006-64.7.

This work includes the image of one of television's early innovators, the comedian and actor Groucho Marx. His quiz show, *You Bet Your Life* (NBC, 1950–61), introduced comedy into the game show format, with Groucho engaging guests in humorous, clever, and often improvisational conversation.

SELECTED BIBLIOGRAPHY

Acham, Christine. *Revolution Televised: Prime Time and the Struggle for Black Power*. Minneapolis: University of Minnesota Press, 2005.

Alloway, Lawrence. "The Arts and the Mass Media." *Architectural Design* 28, no. 2 (February 1958): 84–85.

Andrew, Dudley, and Steven Unger. *Popular Front Paris and the Poetics of Culture*. Cambridge, MA: Harvard University Press, 2005.

Art in Our Time: An Exhibition to Celebrate the Tenth Anniversary of the Museum of Modern Art and the Opening of Its New Building, Held at the Time of the New York World's Fair. New York: The Museum of Modern Art, 1939.

Autograph 5: Lou Dorfsman. New York: Baruch College, 1975.

Banes, Sally. *Greenwich Village 1963: Avant-Garde Performance and the Effervescent Body*. Durham, NC: Duke University Press, 1993.

Barnouw, Erik. *Tube of Plenty: The Evolution of American Television*. 2nd ed. New York: Oxford University Press, 1990.

Bass, Jennifer, and Pat Kirkham. *Saul Bass: A Life in Film and Design*. London: Laurence King, 2011.

Battaglio, Stephen. *David Susskind: A Televised Life*. New York: St. Martin's, 2010.

Benhamou-Huet, Judith, ed. *Warhol TV*. Paris: La Maison Rouge, 2009.

Benjamin, Walter. "The Work of Art in the Age of Mechanical Reproduction." In *Illuminations: Essays and Reflections*, edited by Hannah Arendt, translated by Harry Zohn, 219–53. New York: Harcourt, Brace and World, 1968.

Berger, Maurice. "Abstract Expressionism: A Cultural Timeline, 1940–1976." In *Action/Abstraction: Pollock, de Kooning, and American Art, 1940–1976*, edited by Norman Kleeblatt, 14–41. New York: The Jewish Museum, and New Haven: Yale University Press, 2008.

———. "Andy Warhol's 'Pleasure Principle.'" In Jonathan Binstock, *Andy Warhol: Social Observer*, 23–31. Philadelphia: Pennsylvania Academy of the Fine Arts, 2000.

———. *For All the World to See: Visual Culture and the Struggle for Civil Rights*. New Haven: Yale University Press, 2010.

———. *Labyrinths: Robert Morris, Minimalism, and the 1960s*. New York: Harper and Row, 1989.

———. "The Mouse That Never Roars: Jewish Masculinity on American Television." In *Too Jewish? Challenging Traditional Identities*, edited by Norman Kleeblatt, 93–107. New Brunswick, NJ: Rutgers University Press, 1996.

Bianculli, David. *Dangerously Funny: The Uncensored Story of* The Smothers Brothers Comedy Hour. New York: Simon and Schuster, 2009.

Boddy, William. *Fifties Television: The Industry and Its Critics*. Urbana: University of Illinois Press, 1990.

Bogart, Leo. *The Age of Television: A Study of Viewing Habits and the Impact of Television on American Life*. 2nd ed. New York: Frederick Ungar, 1958.

Bogart, Michele H. "Modernism and Advertising Art." In *Artists, Advertising, and the Borders of Art*, 137–43. Chicago: University of Chicago Press, 1995.

Booker, M. Keith. *Strange TV: Innovative Television from* The Twilight Zone *to* The X-Files. Westport, CT: Praeger, 2002.

Brown, Les. *Television: The Business behind the Box*. New York: Harcourt Brace Jovanovich, 1971.

Browne, Nick. "The Political Economy of the Television (Super) Text." *Quarterly Review of Film Studies* 9, no. 3 (Summer 1984): 174–82.

Burdick, Eugene, et al. *The Eighth Art: Twenty-Three Views of Television Today*. New York: Holt, Rinehart and Winston, 1962.

Castells, Manuel. *The Rise of the Network Society*. Malden, MA: Blackwell, 1996.

Clark, T. J. *Farewell to an Idea: Episodes from a History of Modernism*. New Haven: Yale University Press, 1999.

Cockcroft, Eva. "Abstract Expressionism, Weapon of the Cold War." *Artforum* 12, no. 10 (June 1974): 39–41.

Connally, Maeve. *TV Medium: Contemporary Art and the Age of Television*. Bristol, UK: Intellect, 2014.

Crary, Jonathan. *Techniques of the Observer: On Vision and Modernity in the Nineteenth Century*. Cambridge, MA: MIT Press, 1990.

Crow, Thomas. *Modern Art in the Common Culture*. New Haven: Yale University Press, 1996.

Davis, Douglas, and Allison Simmons, eds. *The New Television: A Public/Private Art*. Cambridge, MA: MIT Press, 1977.

Dickerman, Leah, et al. *Dada: Zurich, Berlin, Hannover, Cologne, New York, Paris*. Washington, DC: National Gallery of Art, 2005.

Dickstein, Morris. *Gates of Eden: American Culture in the Sixties*. New York: Basic Books, 1977.

Doordan, Dennis P. "Design at CBS." *Design Issues* 6, no. 2 (Spring 1990): 4–17.

Elligott, Michelle. "The Art of Broadcasting: The Museum of Modern Art and Television." *Esopus*, no. 15 (Fall 2010): 148–63.

Farmer, John Alan. *The New Frontier: Art and Television, 1960–65*. Austin: Austin Museum of Art, 2000.

Felleman, Susan. *Art in the Cinematic Imagination*. Austin: University of Texas Press, 2006.

———. "Art Treasures of the Wasteland." *Jump Cut: A Review of Contemporary Media*, no. 52 (Summer 2010). http://www.ejumpcut.org/archive /jc52.2010/fellemanSpigel/.

Fiske, John, and John Hartley. *Reading Television*. London: Methuen, 1978.

Frascina, Francis, ed. *Pollock and After: The Critical Debate*. New York: Harper and Row, 1985.

———, and Charles Harrison, eds. *Modern Art and Modernism: A Critical Anthology*. New York: Harper and Row, 1982.

"Georg Olden: Successful Art Director, Successful Host." *Ebony*, October 1951, 43.

Giddens, Anthony. *The Consequences of Modernity*. Stanford, CA: Stanford University Press, 1990.

Gitlin, Todd. *Inside Prime Time*. New York: Pantheon, 1983.

———. "Prime Time Ideology: The Hegemonic Process in Television Entertainment." In *Television: The Critical View*, edited by Horace Newcomb, 516–36. New York: Oxford University Press, 1994.

Goldberg, RoseLee. *Performance Art: From Futurism to the Present*. New York: Thames and Hudson, 2001.

Golden, Cipe Pineles, Kurt Weihs, and Robert Strunsky, eds. *The Visual Craft of William Golden*. New York: George Braziller, 1962.

Golden, William. "The Art Director in Television Network Promotion." In *Art Directing for Visual Communication and Selling*, edited by Art Directors Club of New York, 124–26. New York: Hastings House, 1957.

———. "My Eye." *Print* 13, no. 3 (May–June 1959): 32–35. Reprinted in Golden, Weihs, and Strunsky, *The Visual Craft of William Golden*, 151–55.

———. "Type Is to Read," *Typography— U.S.A.* New York: Type Directors Club of New York, 1959. Reprinted in Golden, Weihs, and Strunsky, *The Visual Craft of William Golden*, 13–56.

Greenberg, Clement. "Avant-Garde and Kitsch." *Partisan Review* 6, no. 5 (Fall 1939): 34–49.

Greene, Doyle. *Politics and the American Television Comedy: A Critical Survey from* I Love Lucy *through* South Park. Jefferson, NC: McFarland, 2008.

Guilbaut, Serge. "The New Adventures of the Avant-Garde in America." *October* 15 (Winter 1980): 61–78.

Haralovich, Mary Beth. "Sitcoms and Suburbs: Positioning the 1950s Homemaker." In *Private Screenings: Television and the Female Consumer*, edited by Lynn Spigel and Denise Mann, 111–41. Minneapolis: University of Minnesota Press, 1992.

Harris, Steven. *Surrealist Art and Thought in the 1930s: Art, Politics, and the Psyche*. Cambridge: Cambridge University Press, 2004.

Hartley, John. *Uses of Television*. London: Routledge, 1999.

Harvey, Michelle. "Through the Enchanted Gate: The Modern on TV." *MoMA* 4, no. 7 (September 2001): 27–29.

Haviv, Sagi. "The CBS Eye Logo." In *I Heart Design: Remarkable Graphic Design Selected by Designers, Illustrators, and Critics*, edited by Steven Heller, 108. Beverly, MA: Rockport, 2011.

Hess, Dick, and Marion Muller. *Dorfsman and CBS*. New York: American Showcase, 1987.

Hilmes, Michele. *Only Connect: A Cultural History of Broadcasting in the United States*. Belmont, CA: Wadsworth, 2001.

Horkheimer, Max, and Theodor W. Adorno. "The Culture Industry: Enlightenment as Mass Deception." In *Dialectic of Enlightenment*, translated by John Cummings, 120–67. New York: Herder and Herder, 1972.

Joselit, David. *Feedback: Television against Democracy*. Cambridge, MA: MIT Press, 2007.

Keller, Florian. *Andy Kaufman: Wrestling with the American Dream*. Minneapolis: University of Minnesota Press, 2005.

Kepes, Gyorgy. *Language of Vision*. Chicago: Paul Theobald, 1944.

Kleeblatt, Norman, ed. *Action/Abstraction: Pollock, de Kooning, and American Art, 1940–1976*. New York: The Jewish Museum, and New Haven: Yale University Press, 2008.

———. *Too Jewish? Challenging Traditional Identities*. New York: The Jewish Museum, and New Brunswick, NJ: Rutgers University Press, 1996.

Klein, Mason. *Alias Man Ray: The Art of Reinvention*. New York: The Jewish Museum, and New Haven: Yale University Press, 2009.

Kovacs, Ernie. *How to Talk at Gin*. New York: Doubleday, 1962.

——. *Zoomar*. New York: Doubleday, 1957.

Kozloff, Max. "American Painting during the Cold War." *Artforum* 11, no. 9 (May 1973): 43–54.

Krauss, Rosalind. "Video: The Aesthetics of Narcissism." *October* 1 (Spring 1976): 50–64.

Lasky, Julie. "The Search for Georg Olden." In *Graphic Design History*, edited by Steven Heller and Georgette Balance, 115–28. New York: Allworth, 2001.

Lavin, Maud. *Clean New World: Culture, Politics, and Graphic Design*. Cambridge, MA: MIT Press, 2002.

Lichtenstein, Therese. *Twilight Visions: Surrealism and Paris*. Berkeley: University of California Press, 2009.

Lipsitz, George. "The Meaning of Memory: Family, Class, and Ethnicity in Early Network Television Programs." In *Private Screenings: Television and the Female Consumer*, edited by Lynn Spigel and Denise Mann, 71–110. Minneapolis: University of Minnesota Press, 1992.

Lupton, Ellen, and J. Abbott Miller, "White on Black on Gray." In *Design Writing Research: Writing on Graphic Design*. New York: Kiosk, 1996.

MacAgy, Douglas. "Fine and Commercial Arts Redefined." *College Art Journal* 9, no. 4 (Summer 1950): 406–11.

McCarthy, Anna. *Ambient Television: Visual Culture and Public Space*. Durham, NC: Duke University Press, 2001.

McLuhan, Marshall. *The Gutenberg Galaxy: The Making of Typographic Man*. Toronto: University of Toronto Press, 1962.

——. *Understanding Media: The Extensions of Man*. New York: McGraw-Hill, 1964.

"The Man at the Window," *Ebony*, November 1960, 79–85.

Miller, Marc H. *Television's Impact on Contemporary Art*. Flushing, NY: The Queens Museum, 1986.

Newcomb, Horace. "Studying Television: Same Questions, Different Contexts." *Cinema Journal* 45, no. 1 (Autumn 2005): 107–11.

——, ed. *Television: The Critical View*. 7th ed. New York: Oxford University Press, 2007.

——. "This Is Not Al Dente: *The Sopranos* and the New Meaning of 'Television.'" In *Television: The Critical View*, 7th ed., 561–78.

——. *TV: The Most Popular Art*. Garden City, NY: Anchor, 1974.

——, and Robert S. Alley, *The Producer's Medium: Conversations with Creators of American TV*. London: Oxford University Press, 1983.

Pelkonen, Eeva-Liisa, and Donald Albrecht, eds. *Eero Saarinen: Shaping the Future*. New Haven: Yale University Press, 2006.

Peterson, Sidney. *The Dark of the Screen*. New York: Anthology Film Archives and New York University Press, 1980.

——. "The Medium," unpublished manuscript. New York: The Museum of Modern Art, 1955.

Petreycik, Kyle. "When the Joker Was a Contemporary Artist." *Hyperallergic*, March 22, 2013. http://hyperallergic.com/67524/.

"Preserving Our Artistic Heritage," *TV Guide*, July 1, 1967, 23–24.

Press, Andrea L. *Women Watching Television: Gender, Class, and Generation in the American Television Experience*. Philadelphia: University of Pennsylvania Press, 1991.

Rand, Paul. *Thoughts on Design*. New York: Wittenborn, 1947.

Remington, R. Roger, and Barbara J. Hodik. *Nine Pioneers in American Graphic Design*. Cambridge, MA: MIT Press, 1989.

Rosenberg, Bernard, and David Manning White, eds. *Mass Culture: The Popular Arts in America*. Glencoe, IL: Free Press, 1957.

Saarinen, Aline B. *Jacob Lawrence*. New York: American Federation of Arts, 1960.

——. "Levels of Looking," unpublished essay, n.d. Archives of American Art, box 5, folder 6.

——. *The Proud Possessors: The Lives, Times, and Tastes of Some Adventurous American Art Collectors*. New York: Random House, 1958.

Schumer, Arlen. *Visions from* The Twilight Zone. San Francisco: Chronicle, 1990.

Serling, Rod. *New Stories from* The Twilight Zone. New York: Bantam, 1962.

——. *Requiem for a Heavyweight: A Reading Version of the Dramatic Script*. New York: Bantam, 1962.

——. *Stories from the Twilight Zone*. New York: Bantam, 1960.

Shaw, Nancy Alison. "Modern Art, Media Pedagogy and Cultural Citizenship: The Museum of Modern Art Television Project, 1952–1955." PhD diss., McGill University, 2000.

Smith, Richard Cándida. *Utopia and Dissent: Art, Poetry, and Politics in California*. Berkeley: University of California Press, 1995.

Spigel, Lynn. *Make Room for TV: Television and the Family Ideal in Postwar America*. Chicago: University of Chicago Press, 1992.

———. "Portable TV: Studies in Domestic Space Travel." In *Welcome to the Dreamhouse: Popular Media and Postwar Suburbs*, 60–103. Durham, NC: Duke University Press, 2001.

———. *TV by Design: Modern Art and the Rise of Network Television*. Chicago: University of Chicago Press, 2009.

———, and Jan Olsson, eds. *Television after TV: Essays on a Medium in Transition*. Durham, NC: Duke University Press, 2004.

Spiteri, Raymond, and Donald LaCross. *Surrealism, Politics, and Culture*. Aldershot, U.K.: Ashgate, 2003.

The Vision of Ernie Kovacs. New York: Museum of Broadcasting, 1986.

Wade, Robert J. *Designing for TV: The Arts and Crafts in Television Production*. New York: Pellegrini and Cudahy, 1952.

Walz, Robin. *Pulp Surrealism: Insolent Popular Culture in Early Twentieth-Century Paris*. Berkeley: University of California Press, 2000.

Warhol, Andy, and Pat Hackett. *POPism: The Warhol '6os*. New York: Harcourt Brace Jovanovich, 1980.

Wasson, Haidee. *Museum Movies: The Museum of Modern Art and the Birth of Art Cinema*. Berkeley: University of California Press, 2005.

Weinstein, David. *The Forgotten Network: DuMont and the Birth of American Television*. Philadelphia: Temple University Press, 2006.

Williams, Raymond. *Television: Technology and Cultural Form*. New York: Schocken, 1974.

Williamson, Judith. *Consuming Passions: The Dynamics of Popular Culture*. London: Marion Boyars, 1986.

———. *Decoding Advertising: Ideology and Meaning in Advertising*. London: Marion Boyars, 1978.

Wolfe, Peter. *In the Zone: The Twilight World of Rod Serling*. Bowling Green, OH: Bowling Green State University Popular Press, 1997.

INDEX

CREDITS AND PERMISSIONS

The photographers, sources of visual material other than the owners indicated in the captions, and copyright holders are listed below. Every reasonable effort has been made to supply complete and correct credits; if there are errors or omissions, please contact Yale University Press or the Jewish Museum so that corrections can be addressed in any subsequent edition. Material in copyright is reprinted by permission of copyright holders or under fair use.

Page numbers are **bold**.

Cover, 108, 112–13: Videos © The Andy Warhol Museum, Pittsburgh, PA, a museum of Carnegie Institute, All rights reserved; video stills provided by The Andy Warhol Museum. **ii, 140:** Artwork © James Rosenquist / licensed by VAGA, New York, NY. Private collection. **16–17:** Artwork © Succession Marcel Duchamp / ADAGP, Paris / Artists Rights Society (ARS), New York; Musée National d'Art Moderne, Centre Georges Pompidou, Paris; photograph by Jean-Claude Planchet, Musée National d'Art Moderne, Centre Georges Pompidou, Paris; photograph © CNAC/MNAM/Distributor RMN-Grand Palais / Art Resource, NY. **18 top:** Artwork © Salvador Dalí, Fundació Gala-Salvador Dalí, Artists Rights Society (ARS), New York; digital image © Museum of Modern Art / licensed by SCALA / Art Resource, NY; collection of The Museum of Modern Art 162.1934, given anonymously. **19 top:** Artwork © Succession Marcel Duchamp / ADAGP, Paris / Artists Rights Society (ARS), New York; Philadelphia Museum of Art, Bequest of Katherine S. Dreier, 1952; photograph provided by Philadelphia Museum of Art / Art Resource, NY. **20, 23, 32–33:** Artworks © C. Herscovici, Brussels / Artists Rights Society (ARS), New York; **20:** photograph © Christie's Images / Bridgeman Art Library; **23:** collection of The Museum of Modern Art, Gift of Richard S. Zeisler, photograph by Gianni Dinni Dagli Orti / Art Archive at Art Resource, NY. **32–33:** Artwork © C. Herscovici, Brussels / Artists Rights Society (ARS), New York; digital image © Museum of Modern Art / licensed by

SCALA / Art Resource, NY. **25:** Artwork © Artists Rights Society (ARS), New York / ADAGP, Paris; collection of the Jewish Museum, New York, Gift of Alex Schmelzer and Lisa Rotmil, 2006–27. **26:** Artwork © Estate of Herbert Ferber, collection of the Jewish Museum, New York, Purchase: Leslie and Roslyn Goldstein Fund, 2004–43. **27:** Artwork © Josef and Yaye Breitenbach Foundation; collection of the Jewish Museum, New York, Purchase: Horace W. Goldsmith Foundation Fund, 2009–2. **28.** Image provided by Moviestore collection Ltd / Alamy. **29 top, 34:** Artworks © Man Ray Trust / Artists Rights Society (ARS), NY / ADAGP, Paris; **34:** Digital image © Museum of Modern Art / licensed by SCALA / Art Resource, NY; collection of The Museum of Modern Art, James Thrall Soby Fund. **38:** Photograph © Ezra Stoller / Esto, All rights reserved. **39 left and right:** Photographs © Bill Maris / Esto, All rights reserved. **40, 138:** Reprinted with permission from Architectural Record, © 2014 McGraw-Hill Financial, www.architecturalrecord.com. **41:** Collection of the Jewish Museum, New York, Gift of Dolores S. Taller in Memory of Stephen Taller, 2001–1. **42 top left and right:** Artwork © Estate of Ben Shahn / Licensed by VAGA, New York, collection of the Jewish Museum, New York, Purchase: Kristie A. Jayne Fund, 1999–169.1, 1999–169.3, 1999–169.2; photographs by Sheldan Collins. **50:** Image © The Granger Collection Ltd. **57 top:** Artwork © Alberto Giacometti Estate / licensed by VAGA and ARS, New York. **58 right:** Artwork © Estate of Roy Lichtenstein; digital image © Museum of Modern Art / licensed by SCALA / Art Resource, NY; collection of The Museum of Modern Art, Gift of Philip Johnson. **60:** Designed and created by Harry W. Prickett, written by Louis M. Heyward and illustrated by Norman Mazin. **61:** Video stills © Estate of Stan VanDerBeek; images provided by Electronic Arts Intermix (EAI), New York. **63:** Photograph © RIA Novosti / Alamy. **64:** George Schlatter—Ed Friendly Productions and Romart, Inc. **65 top, 66:** Video stills The Ed Sullivan Show © SOFA Entertainment, www.edsullivan.com. **67:** Artwork © Robert

Morris / Artists Rights Society (ARS), New York; courtesy of Sonnabend Gallery, New York. **68 top:** Artwork © LeWitt Estate / Artists Rights Society (ARS), New York; digital image © Museum of Modern Art / licensed by SCALA / Art Resource, NY; collection of The Museum of Modern Art, New York; Gift of Agnes Gund and purchase (by exchange). **68 bottom:** Jewish Museum archive. **69:** Artwork © Larry Bell; collection of the Addison Gallery of American Art, gift of Frank Stella (PA 1954), Addison Art Drive, 1991.40. **70–71:** Artwork © Artists Rights Society (ARS), New York / ADAGP, Paris; collection of the Jewish Museum, Gift of William Benenson, 1991–49; photographs by John Parnell. **72:** Artwork © Wolfgang's Vault, all rights reserved; digital image © Museum of Modern Art / licensed by SCALA/Art Resource, NY; collection of The Museum of Modern Art, Purchase. **76 top, 77:** Bass Estate–Jennifer Bass [via Academy of Motion Picture Arts and Sciences]. **78 bottom:** Artwork © Agnes Martin / Artists Rights Society (ARS), New York; digital image © Museum of Modern Art / Licensed by SCALA / Art Resource, NY; collection of The Museum of Modern Art, New York; The Riklis Collection of McCrory Corporation. **91:** Collection of The Museum of Modern Art Archives, Victor D'Amico Papers, IV.B.2; digital image © Museum of Modern Art / licensed by SCALA / Art Resource, NY. **92–96, 128 left:** The Museum of Modern Art, New York, Photographic Archive; digital image © Museum of Modern Art / licensed by SCALA / Art Resource, NY; **93:** photograph by Alexandre Georges; **94, 95 bottom:** photograph by Soichi Sunami; **95 top, 96:** photograph by George Barrows. **101 top:** Artwork © Lee Friedlander, image provided by Fraenkel Gallery, San Francisco, and Pace/MacGill Gallery, New York. **101 bottom:** Artwork © Dennis Hopper, image provided by The Hopper Art Trust, www.dennishopper.com. **102 right:** Peter Arno / The New Yorker, © Condé Nast. **106:** Artwork © Estate of Nam June Paik and © Artists Rights Society (ARS), New York / VG Bild-Kunst, Bonn; digital image © Museum of Modern Art / licensed by SCALA / Art Resource, NY; collection

of The Museum of Modern Art, Gift of
the Junior Associates of the Museum of
Modern Art, New York, The Greenwich
Collection Ltd. Fund, and gift of Margot
Ernst. **107 top:** Artwork © Yoko Ono; image
provided by Lenono Photograph Archive.
107 bottom: Artwork ©Nancy Kienholz;
image provided by bpk, Berlin/Hamburger
Kunsthalle/Art Resource, NY; photograph
by Elke Walford/Dirk Dunkelberg. **109:**
Video stills courtesy of the Kramlich
Collection. **111:** Whitney Museum of
American Art, New York; Gift of The
American Contemporary Art Foundation,
Inc., Leonard A. Lauder, President, 2002.
111, 130 top and bottom, 139 left, 145:
Artworks © The Andy Warhol Foundation
for the Visual Arts, Inc., / Artists Rights
Society (ARS), New York; **145:** courtesy
of Ronald Feldman Fine Arts, New York
/ www.feldmangallery.com, collection
of the Jewish Museum, Gift of Lorraine
and Martin Beitler, 2006–64.7. **121:** Image
provided by the Library of Congress. **123
right:** Image provided by the Peabody
Awards, University of Georgia. **124:**
Artwork © The Pollock-Krasner Foundation
/ Artists Rights Society (ARS), New York;
digital image © Museum of Modern Art
/ Licensed by SCALA / Artists Rights
Society (ARS), New York; collection of The
Museum of Modern Art, New York; Gift
of Peggy Guggenheim. **125:** Fletcher6 via
Wikipedia. **126 left:** Image provided by
Alamy stock photos. **132 right:** Artwork ©
R. Hamilton, All Rights Reserved, DACS
and ARS; image provided by the Kunsthalle
Tübingen, Germany, Collection Zundel.
135: Image provided by AP. **136:** Image ©
American Broadcasting Companies, Inc.
137 right: Image provided by Time & Life
Pictures/Getty Images; photograph by Paul
Schutzer. **141 left:** Image © Estate of Nam
June Paik; image provided by Electronic
Arts Intermix (EAI), New York. **141 right:**
WGBH Media Library & Archives. **143
right:** Image provided by Dallas Morning
News / MCT Graphics via Getty Images.
**7 top, 25, 26, 27, 35 bottom, 36, 37, 40,
41, 53, 86, 87, 111, 130 top and bottom,
132 left, 138, 139 left, 145:** Photographs
by Richard Goodbody, Inc.

THE JEWISH MUSEUM
BOARD OF TRUSTEES

OFFICERS

Robert A. Pruzan, Chairman

Jeanette Lerman, Vice Chairman

Betty Levin, Vice Chairman

Benjamin Winter, Vice Chairman

Craig Effron, Vice President

John Shapiro, Vice President

David L. Resnick, Treasurer

Jonathan Crystal, Assistant Treasurer

Debra Fine, Secretary

Amy Rose Silverman, Assistant Secretary

Claudia Gould, Helen Goldsmith
 Menschel Director, ex officio

MEMBERS

Shari Aronson

René-Pierre Azria

Gail A. Binderman

Jacques Brand

Susan Feinstein

Wendy Fisher

Sheri Gellman

Nomi P. Ghez

Meg Goodman

Carol Schapiro Kekst

Francine Klagsbrun

Hirschell Levine

Gustave K. Lipman

Phyllis Mack

Mahnaz Moinian

Joshua Nash*

Margaret Streicker Porres

Michael Rubinoff

Michael C. Slocum

James A. Stern

Teri Volpert

Audrey Wilf

Jane Frieder Wilf

Debra Linhart Wisch

LIFE MEMBERS

Barry J. Alperin**

E. Robert Goodkind*

Eugene Grant

Fanya Gottesfeld Heller

Robert J. Hurst*

Dr. Henry Kaufman

Ellen Liman

Susan Lytle Lipton*

Leni May*

Morris W. Offit*

Amy Rubenstein

H. Axel Schupf*

Stuart Silver

John L. Vogelstein**

Mildred Weissman

ADVISORS

Dr. Arnold M. Eisen

Marc Gary

Jane Leibowitz

*Chairman Emeritus

**President Emeritus